Virtual Pose® 4

The Ultimate Visual Reference Series for Drawing the Human Figure

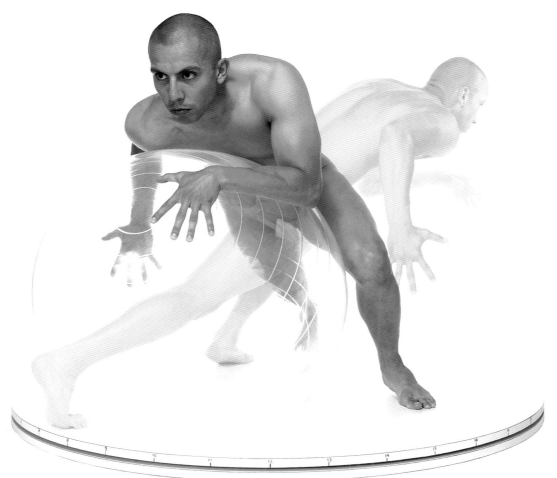

MAC/PC CD-ROM ENCLOSED

Mario Henri Chakkour

Photography by Missy Loewe

Published by Hand Books Press, Gloucester, Massachusetts
Distributed by North Light Books, Cincinnati, Ohio

VIRTUAL POSE® 4
The Ultimate Visual Reference Series for Drawing the Human Figure
by Mario Henri Chakkour

Published by
Hand Books Press
86 Eastern Point Boulevard, Gloucester, MA 01930
info@handbookspress.com
www.handbookspress.com

Distributed by
North Light Books, an imprint of F+W Publications, Inc.
4700 East Galbraith Road, Cincinnati, OH 45236
TEL 513-531-2690, 800-289-0963, FAX 513-891-7185

ISBN-10: 0-9714010-9-8
ISBN-13: 978-0-9714010-9-9

11 10 09 08 07 5 4 3 2 1

Creative Direction: Mario Henri Chakkour
Art Direction: Stephen Bridges
Design: Beth Santos
Photography: Missy Loewe
Photo Assistants: Michelle Simpson, Melissa Demple
Technical Advisor: Salam Dahbour
Research and Choreography: Sandrine Altchoukian

Female Models: (in order of appearance): Aristia, Carina, Shannon, Nadiyah, Ginny, Afinity
Male Models: (in order of appearance): Pablo, Mark

Visit us on the Web: www.virtualpose.net

Printed in Hong Kong

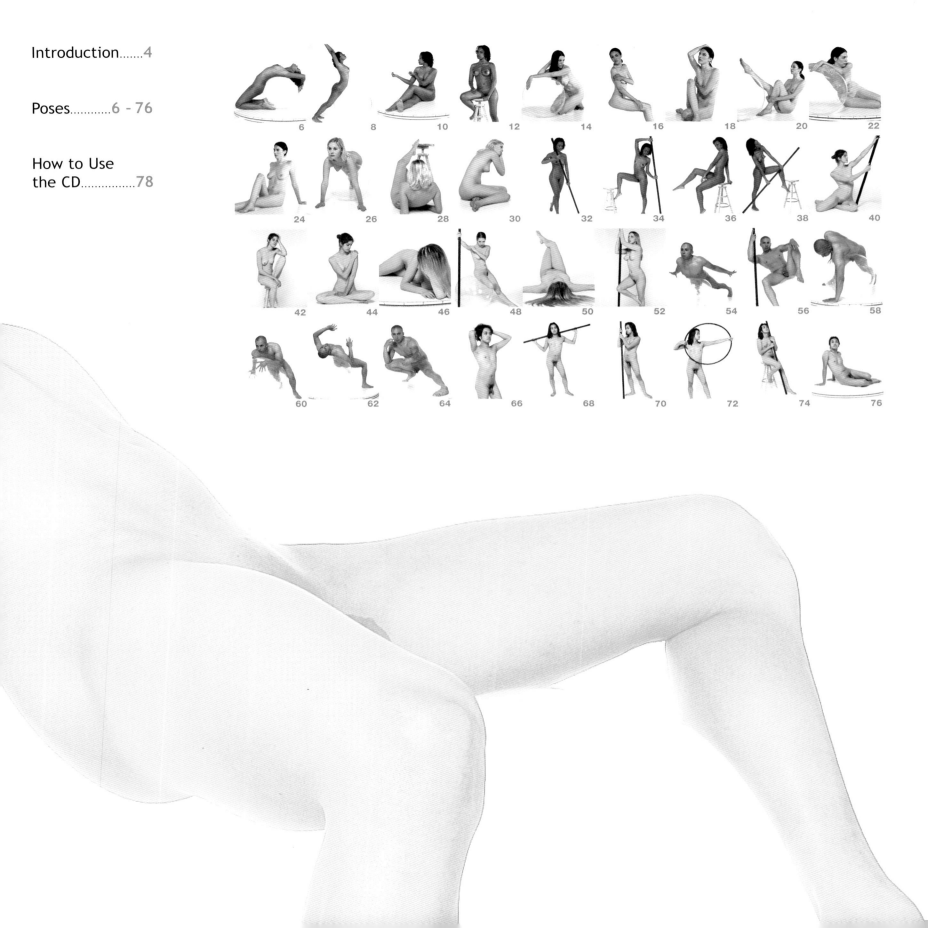

introduction

Welcome to VIRTUAL POSE® 4, the sixth edition in the series that has been providing artists of all levels with the next best thing to working with a live figure model since 1998. In the first two editions (VIRTUAL POSE 1 and 2) we aimed to strike a happy medium by offering poses for reference and tutorial movies with music.

Soon after, and by popular demand, we introduced VIRTUAL POSE 3 which was built on a foundation backed by many letters collected over the course of two years. Then came VIRTUAL POSE CHILDREN & TEENS—a radical departure, featuring clothed and expressive children and teen models. By then, digital photography had come of age radically as well. The newer cameras were faster, more sophisticated, and could capture images with even higher resolution. In 2006 we introduced VIRTUAL POSE DUO premiering paired models working harmoniously. By then, we had addressed just about all the pressing issues brought to our attention by our loyal customers except one in particular, which had been the proverbial holy grail: showcasing poses of a dynamic nature.

And with that, we come to VIRTUAL POSE 4 which earmarks the ultimate rite of passage we had undergone to date in order to capture dynamic poses.

Despite all the knowledge and experience we gathered since the inception of the series, when it came to this issue of featuring action poses, we practically hit a stone wall.

Beyond venturing into uncharted waters, this time we were after the "bigger fish." We soon heard ourselves saying the all too familiar line "We are going to need a bigger boat." In other words, the rotating platform had to be made larger.

It was important to redesign the platform in order to allow the models to assume the kinds of poses that would have been next to impossible to achieve with the older platform—a sleek and elegant icon that has become synonymous with VIRTUAL POSE.

Because it was necessary to maintain design integrity regarding the look and feel of the project, we couldn't just simply introduce a bigger rotating platform that bore no resemblance to its predecessor. We all have become accustomed to the original design, and not merely due to form.

The original platform was a precise measuring instrument that allowed us to turn the model exactly ten degrees at a time, while supporting the right "feel" under its sleek design. It didn't spin out of control when the models stepped on it while allowing smooth rotation. In essence, a fusion of elegance and ingenuity—form and function working seamlessly.

On a parallel track to designing the new platform that met our criteria, we had to contend with the challenge of creating dynamic poses without bulky and unsightly props. While the Auguste Rodin Museum in Paris was the key inspiration for VIRTUAL POSE DUO, would you believe that an infomercial on the benefits of using exercise balls proved to be a eureka moment for VIRTUAL POSE 4? Of course, we couldn't simply use the standard latex balls, especially when many people develop allergic reactions. In addition, the balls had to be as transparent as possible. Let's have a show of hands for ITALY!

While still in Paris working with our choreographer who was showing us some pose ideas, I noticed she was using a particularly elegant bar stool that I simply had to have! However, given this bar stool was purchased over a decade ago, no one could remember where it came from. Our hunt led us to a department store just outside Paris that still manufactured this particular design. FRANCE please take a bow!

Next, came the real challenge which consisted of "test-flying" the exercise balls—by myself.

What followed were the sketches based on those "test-flights", and the occasional bumps and bruises!

Meanwhile, the hardware we ordered from GERMANY worked perfectly. And the master craftsmen in the U.S.A. who designed and built the platform by hand, brought it all together beautifully!

I am proud to say that VIRTUAL POSE 4 is going to appeal to comic book illustrators, as well as traditional artists and sculptors.

featuring *action poses*

Aristia

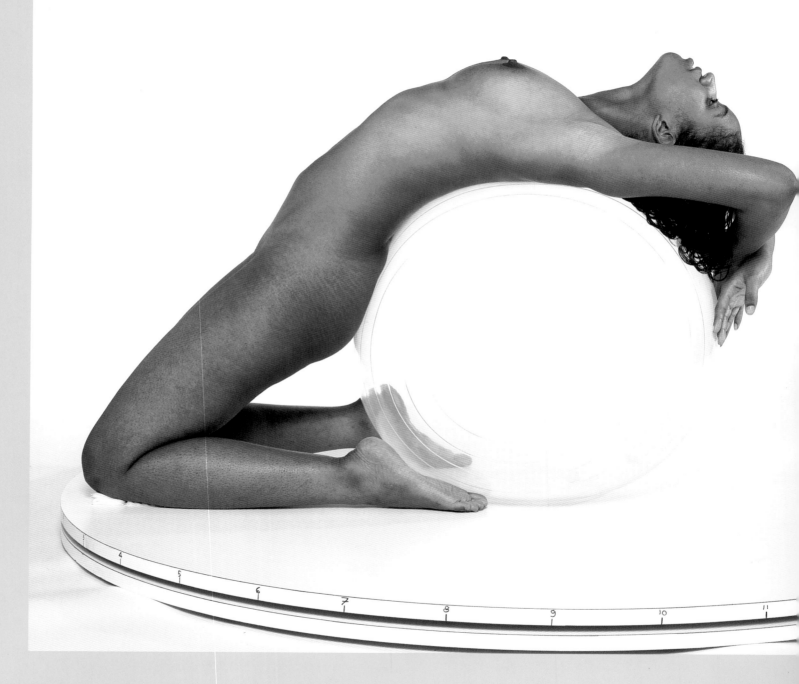

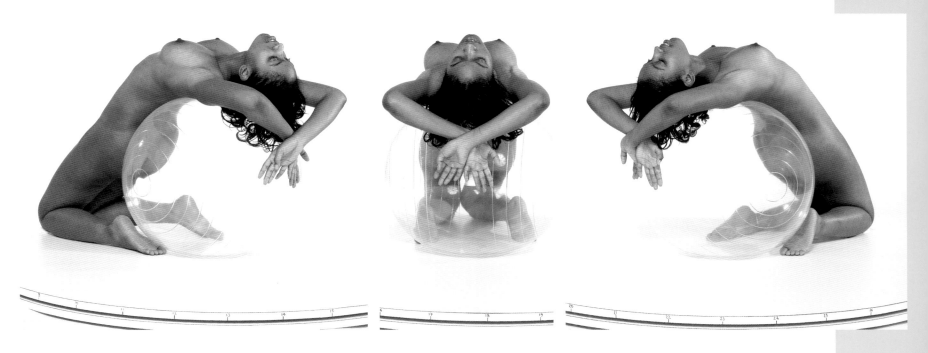

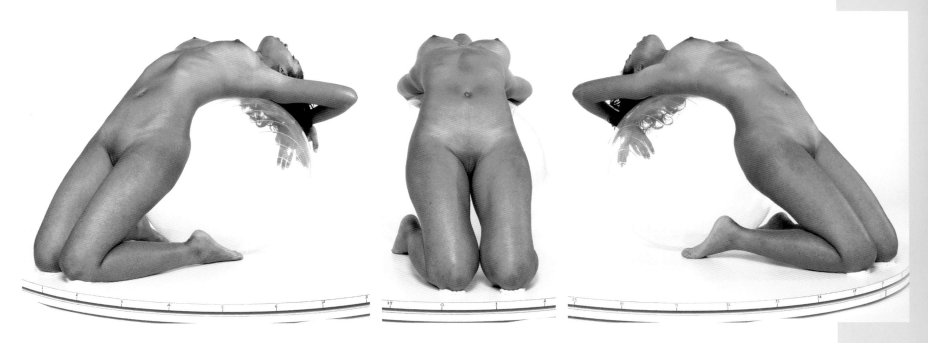

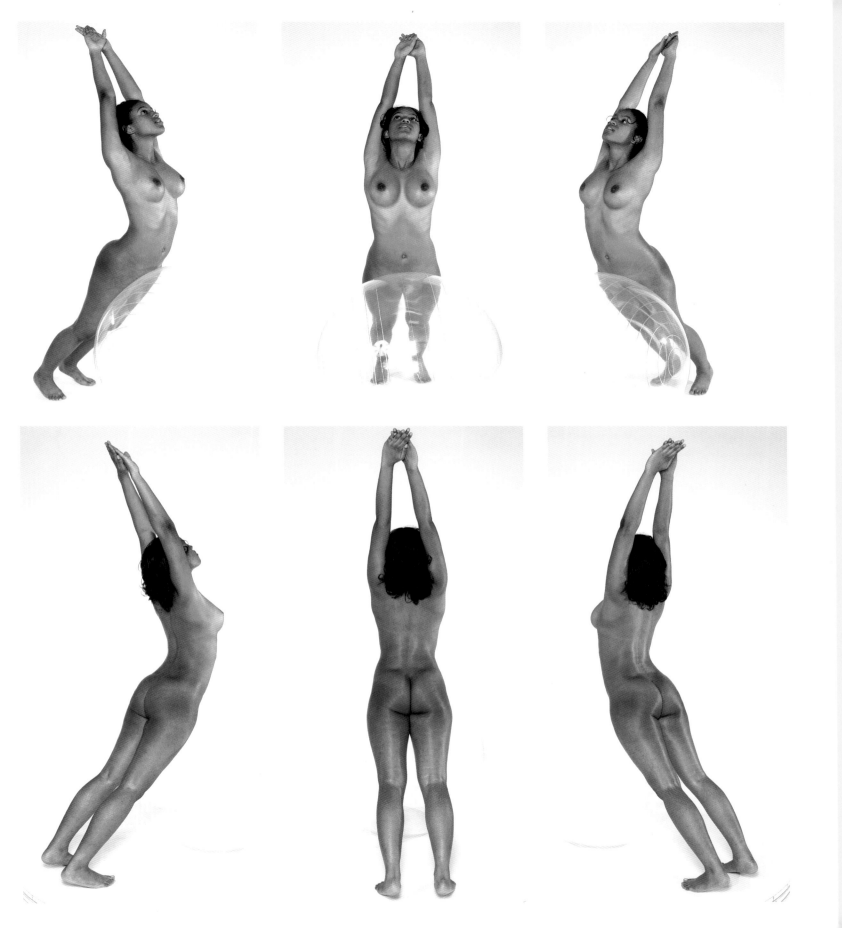

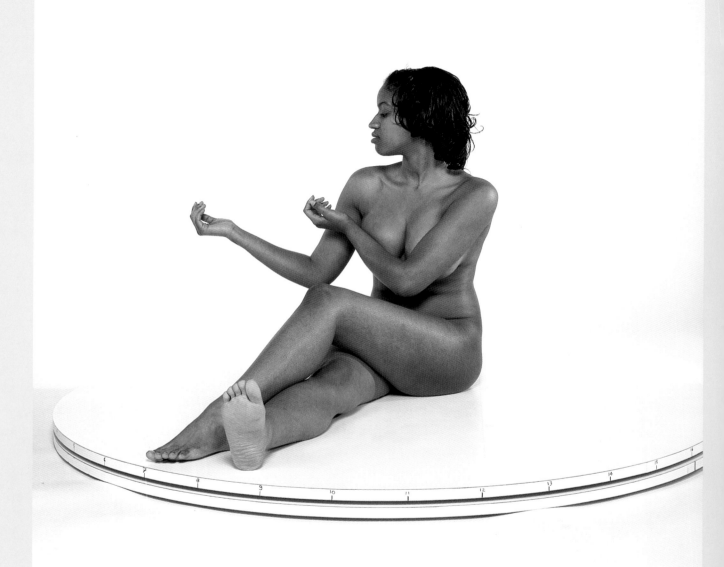

page
10

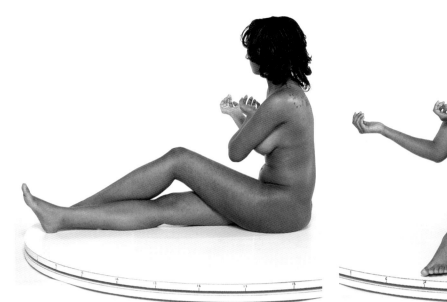
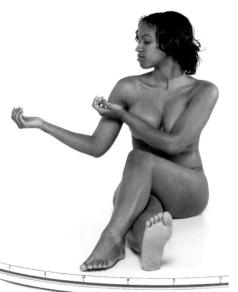
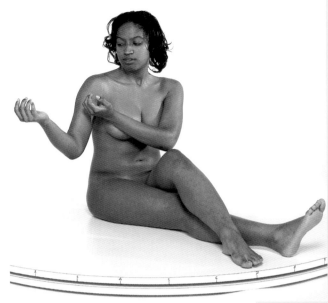
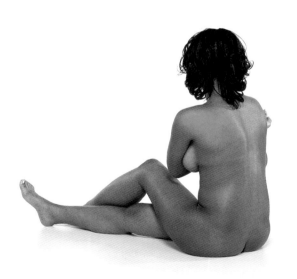
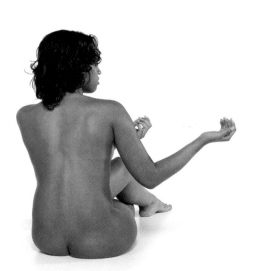
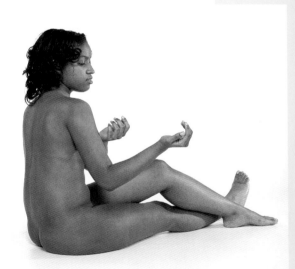

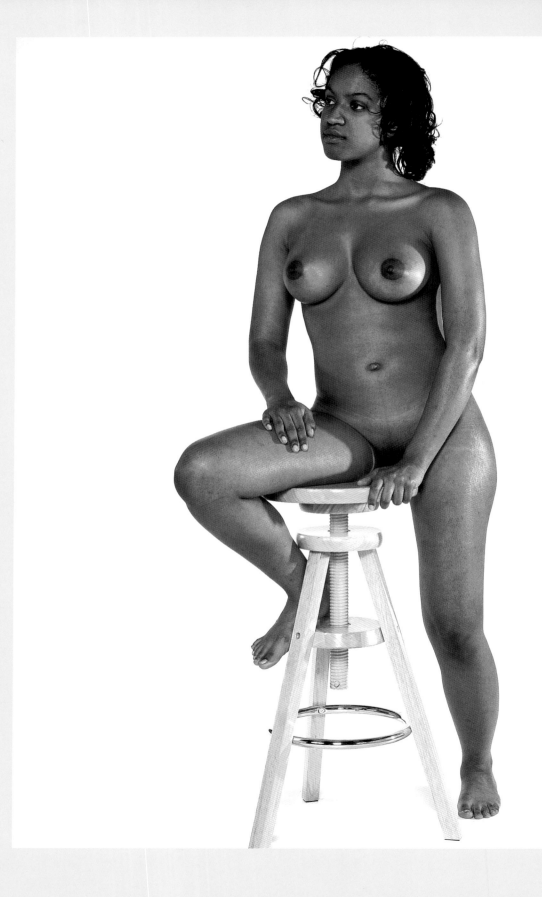

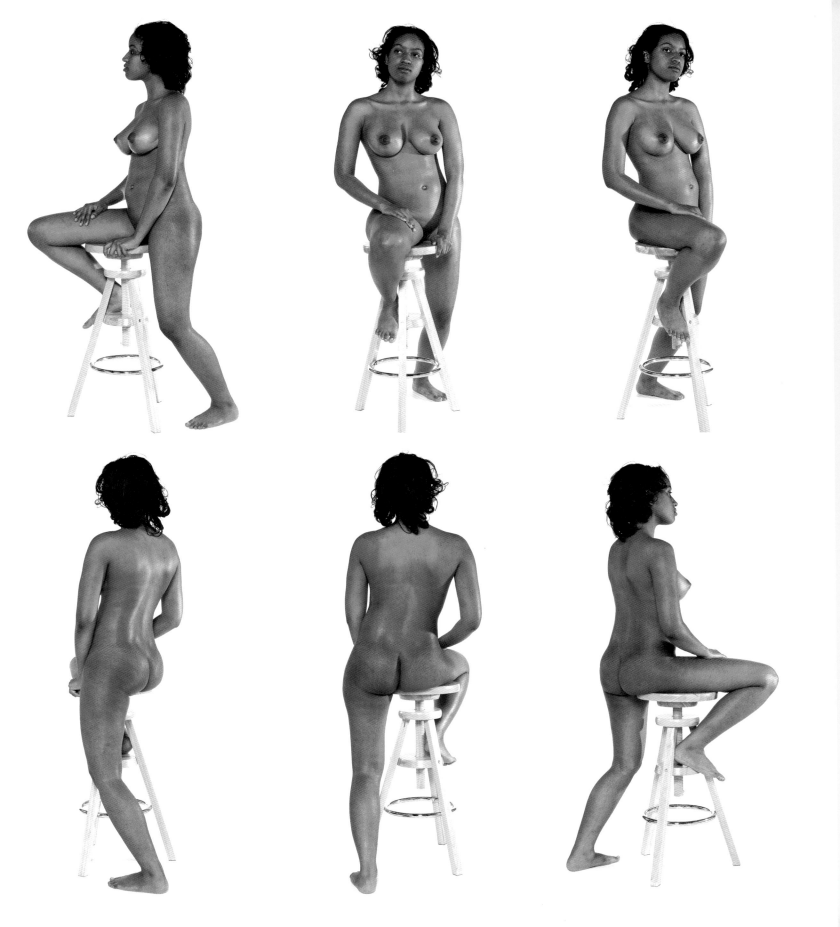

13

Carina

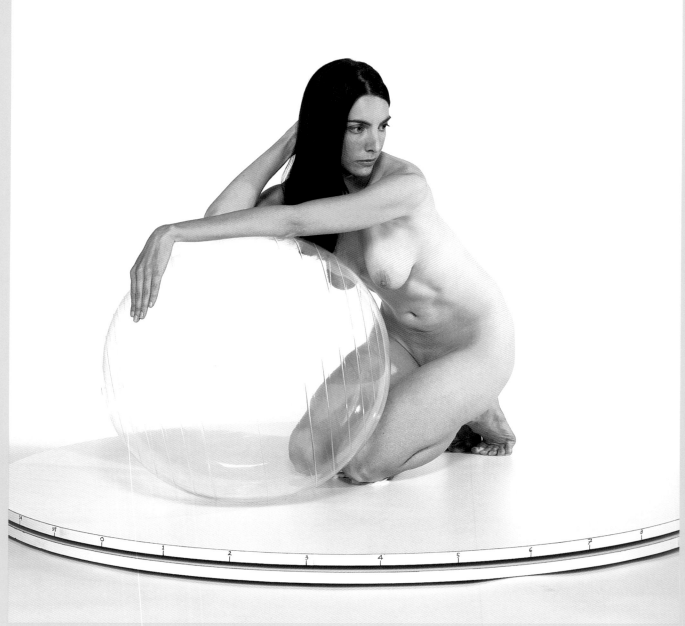

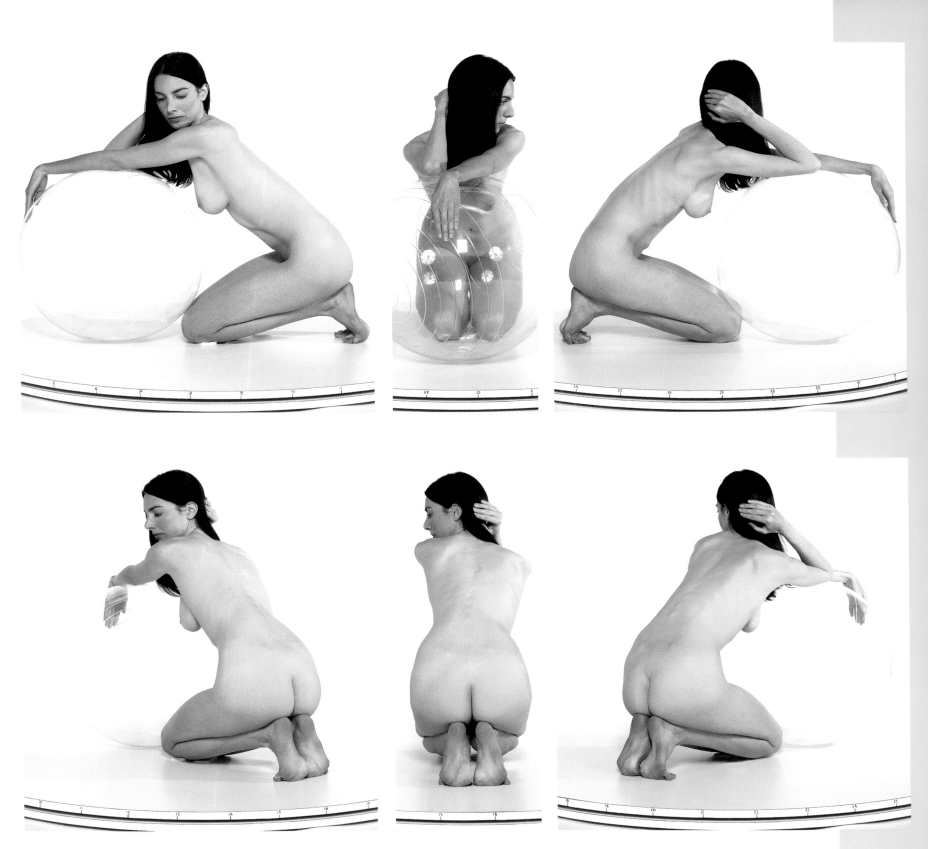

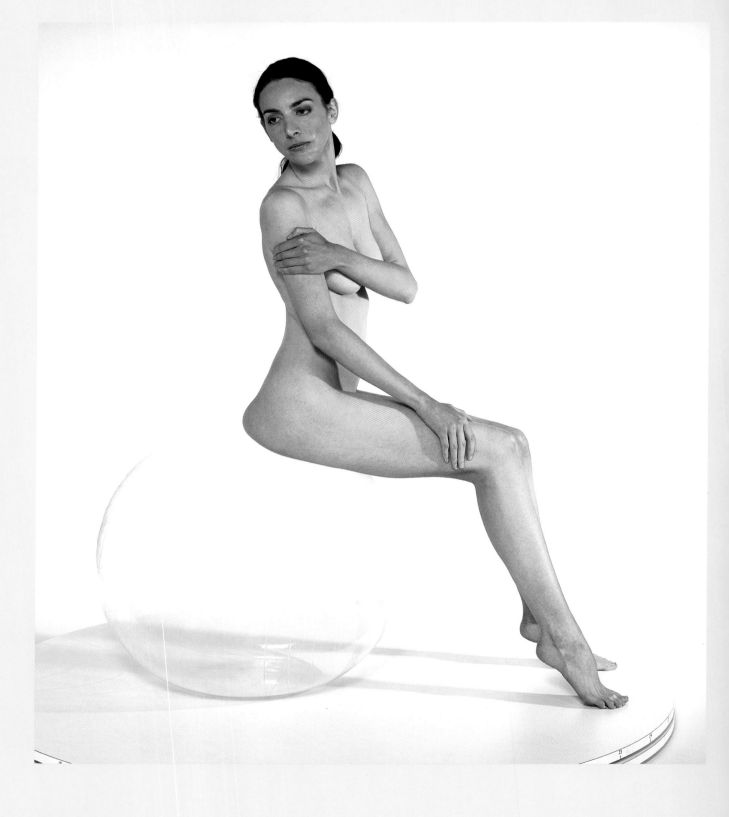

page
16

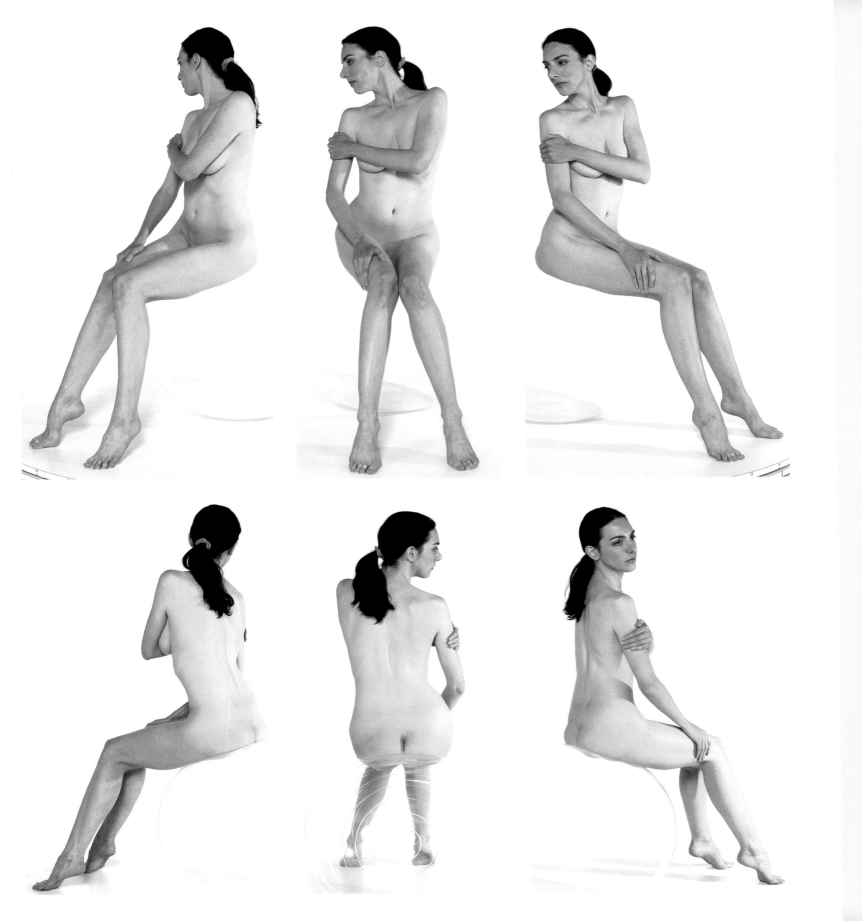

17

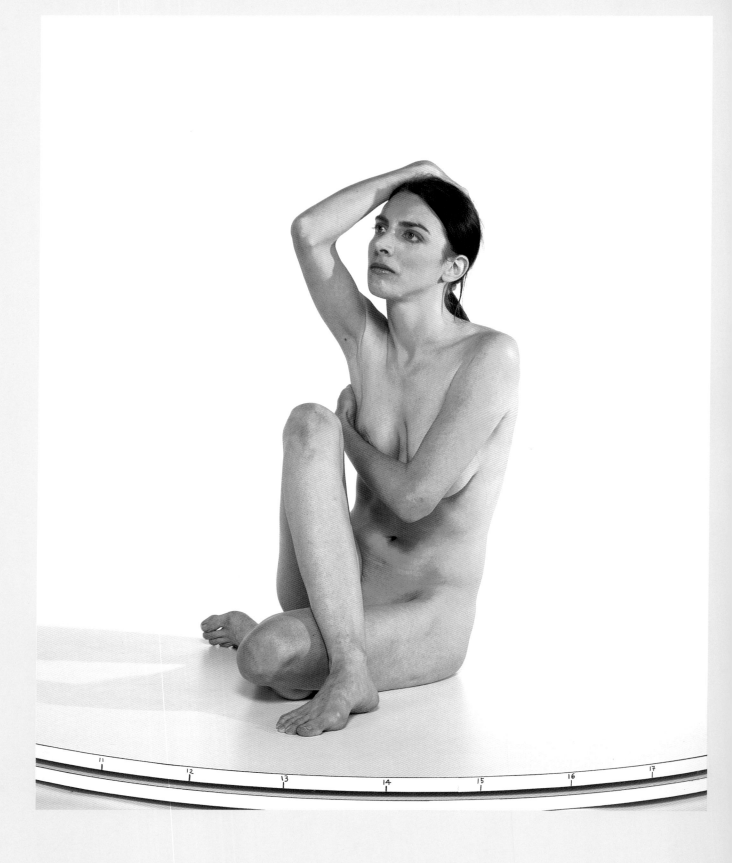

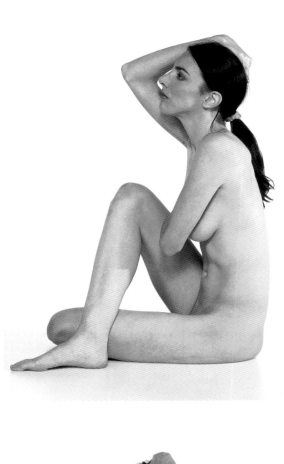
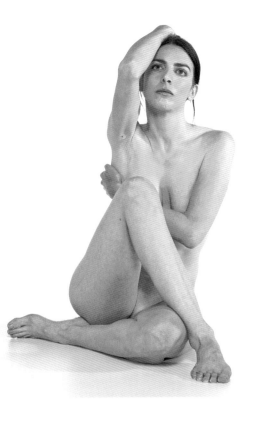
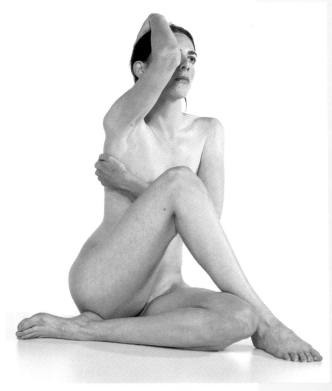
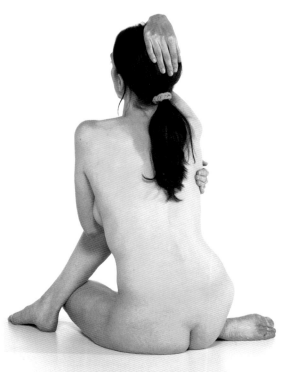
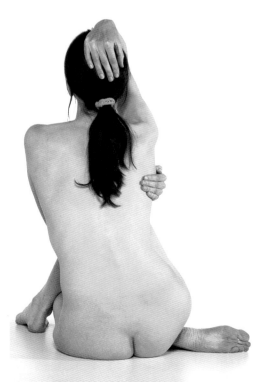
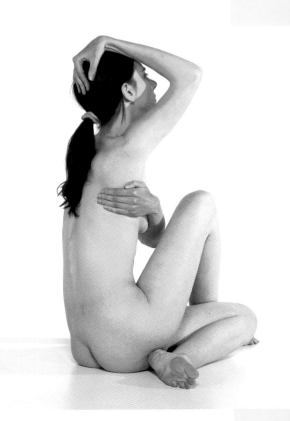

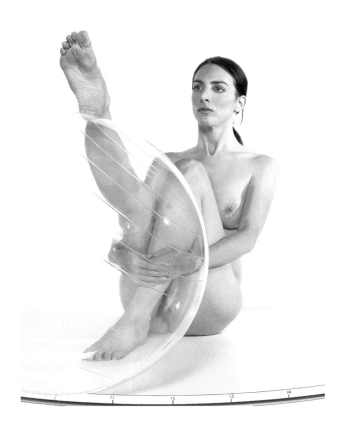
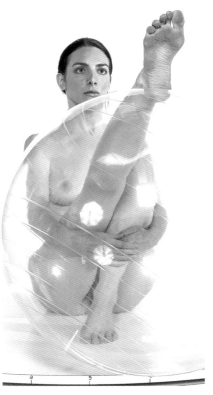
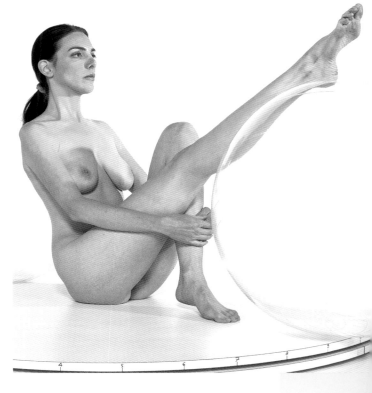
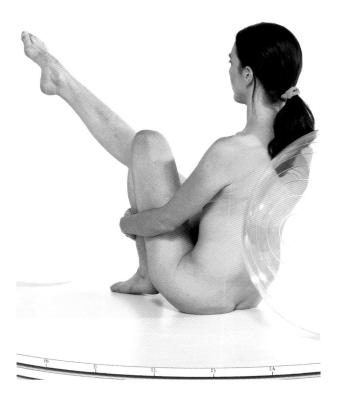
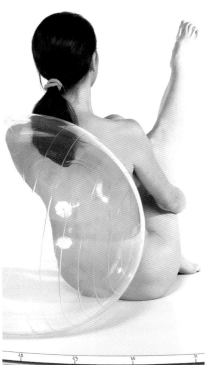
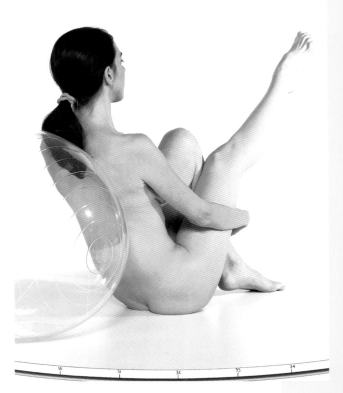

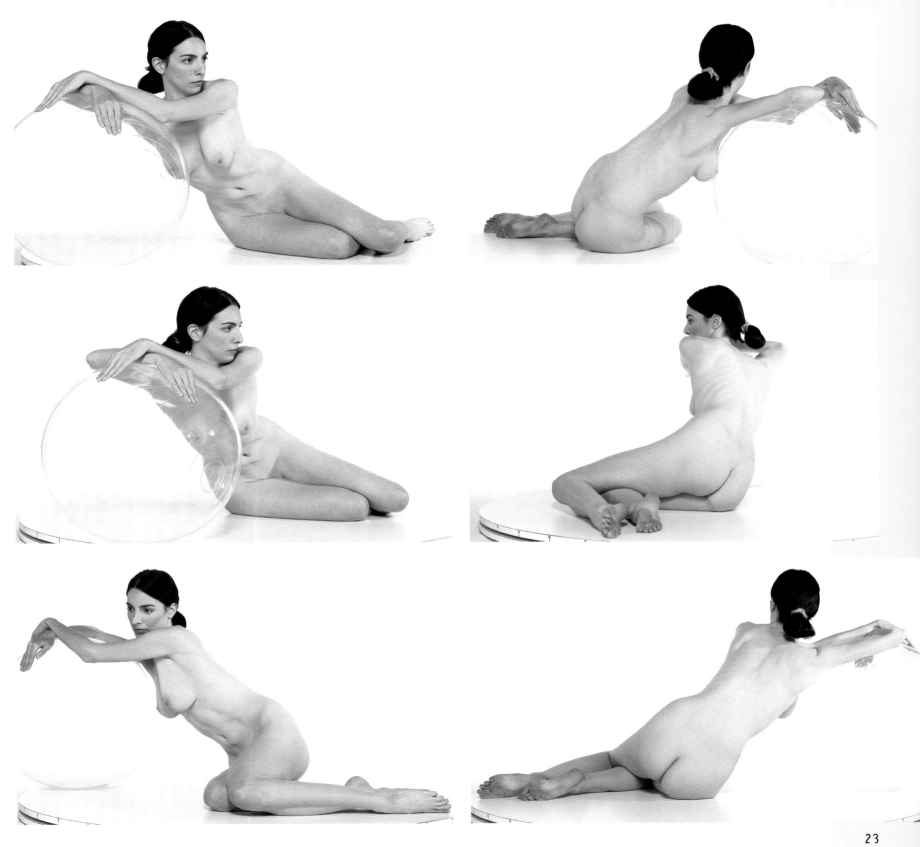

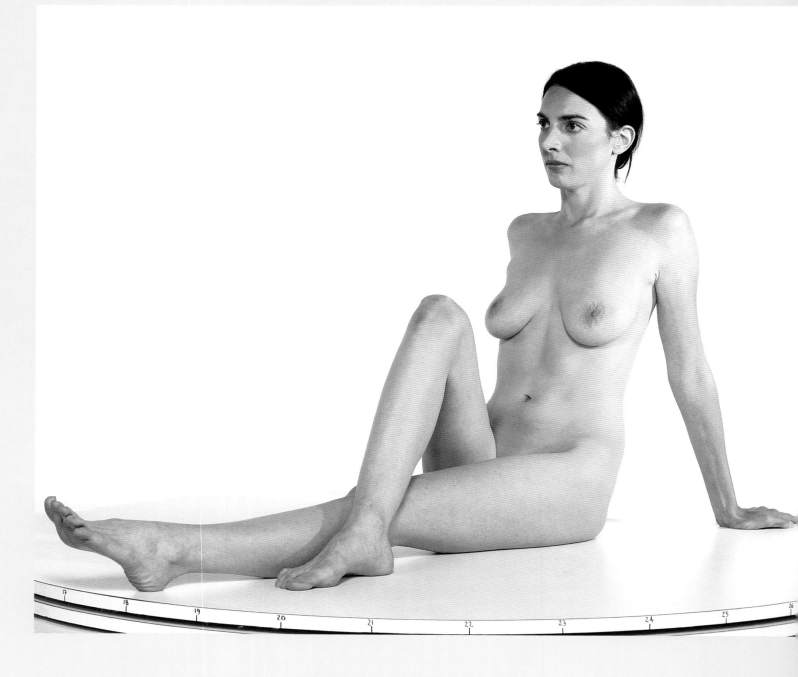

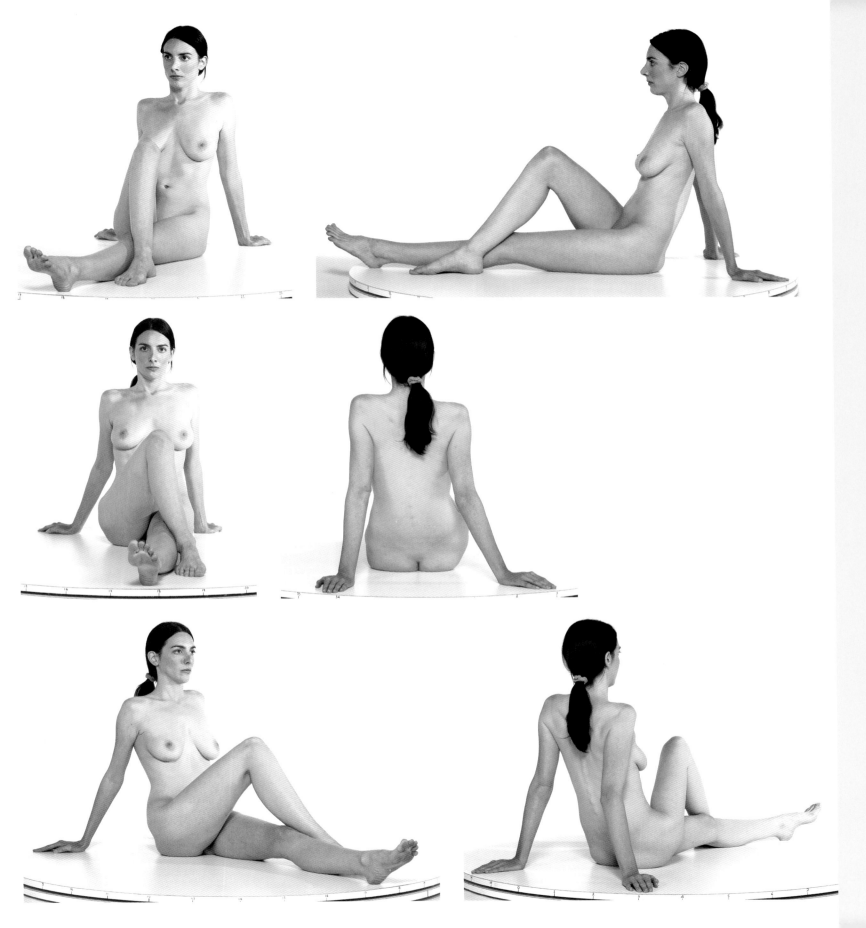

Shannon

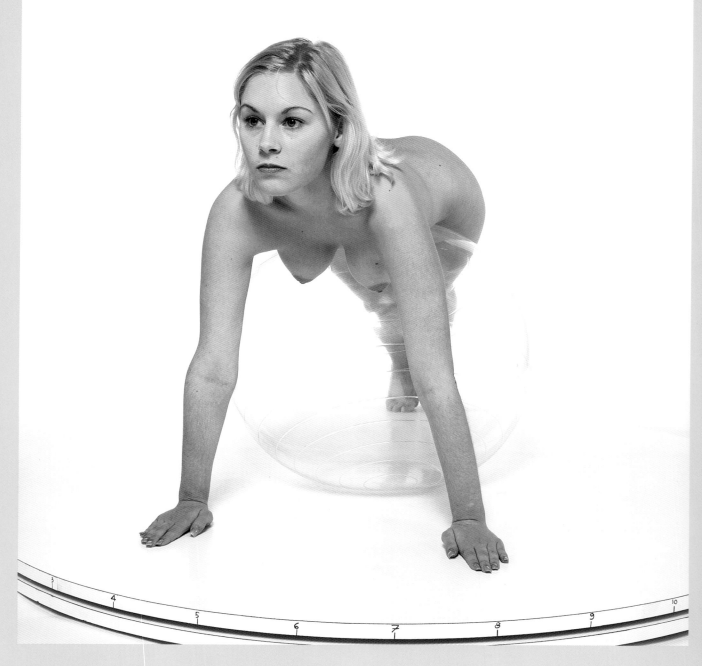

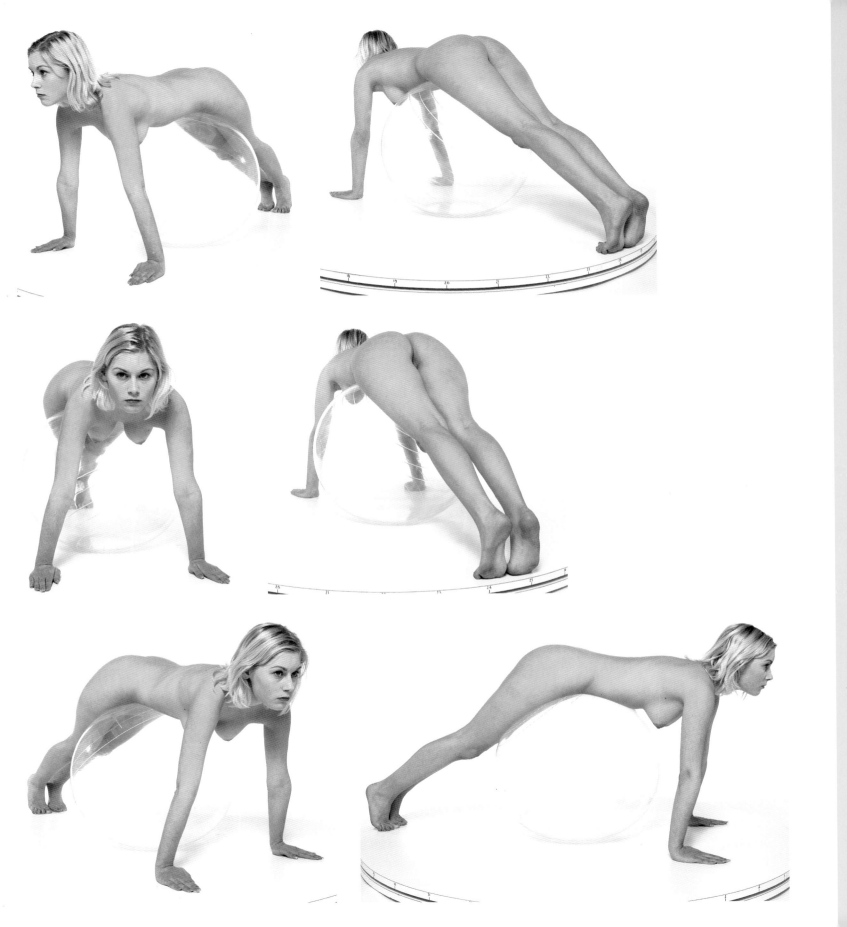

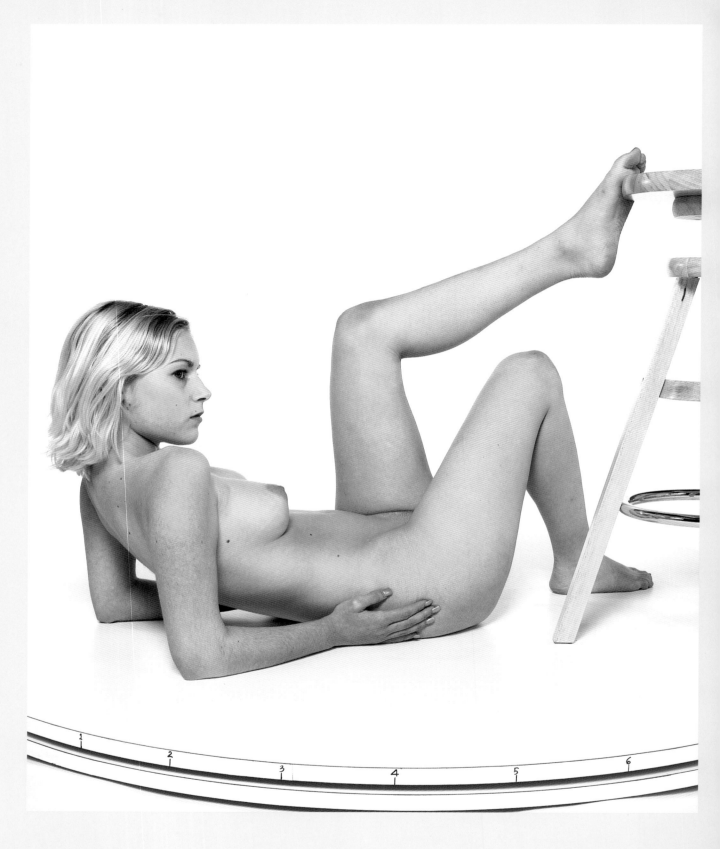

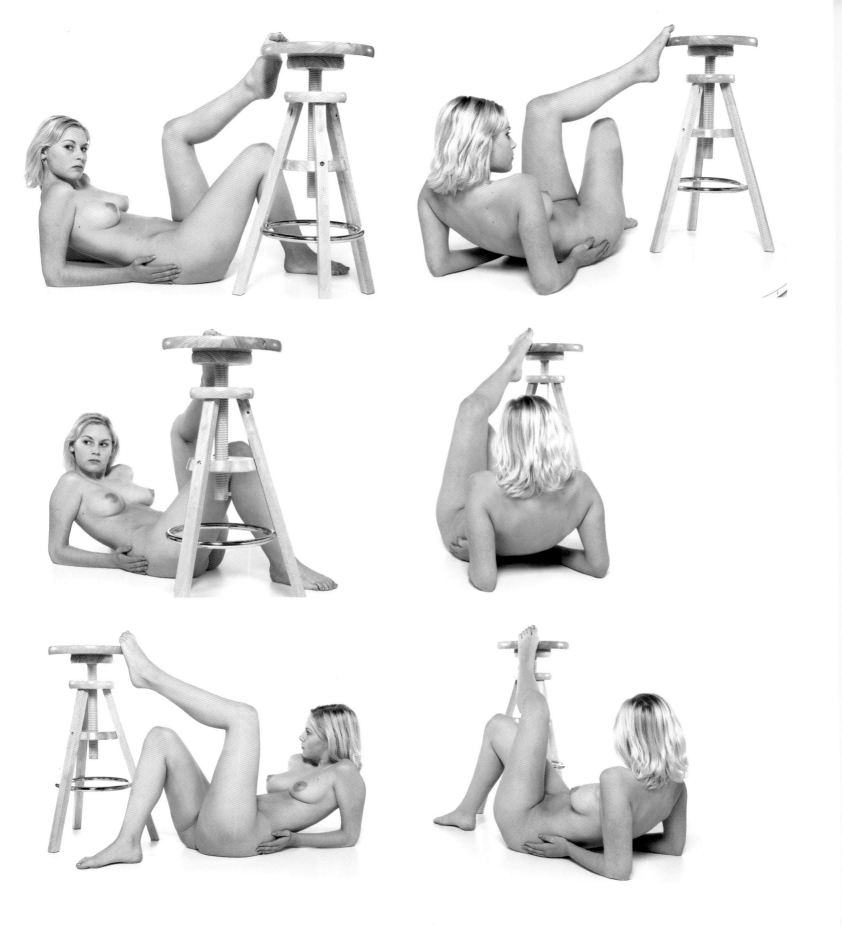

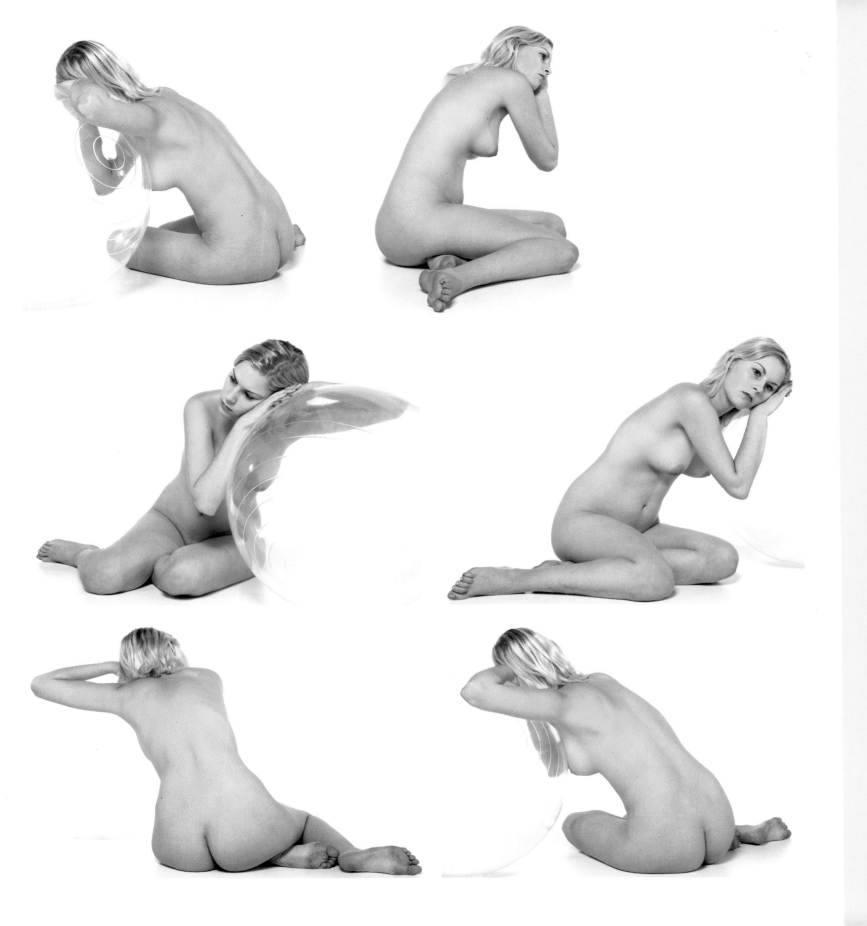

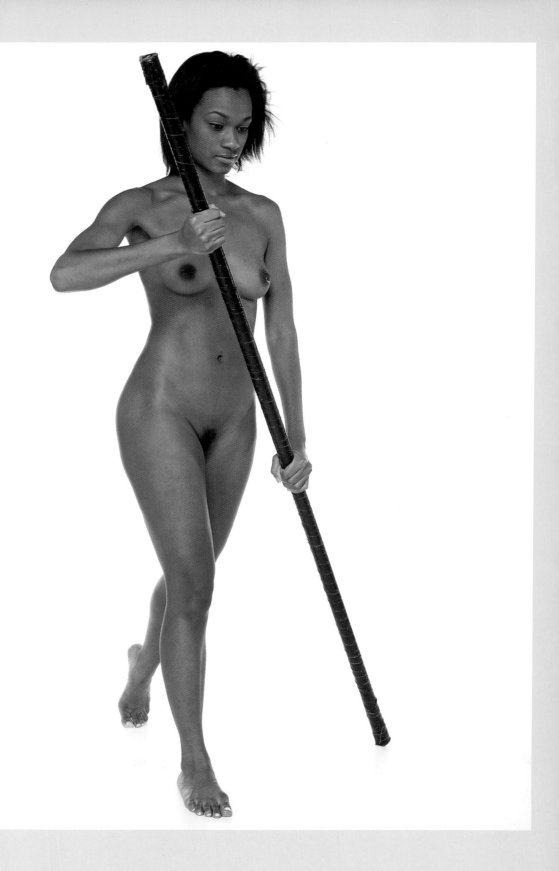

Nadivah

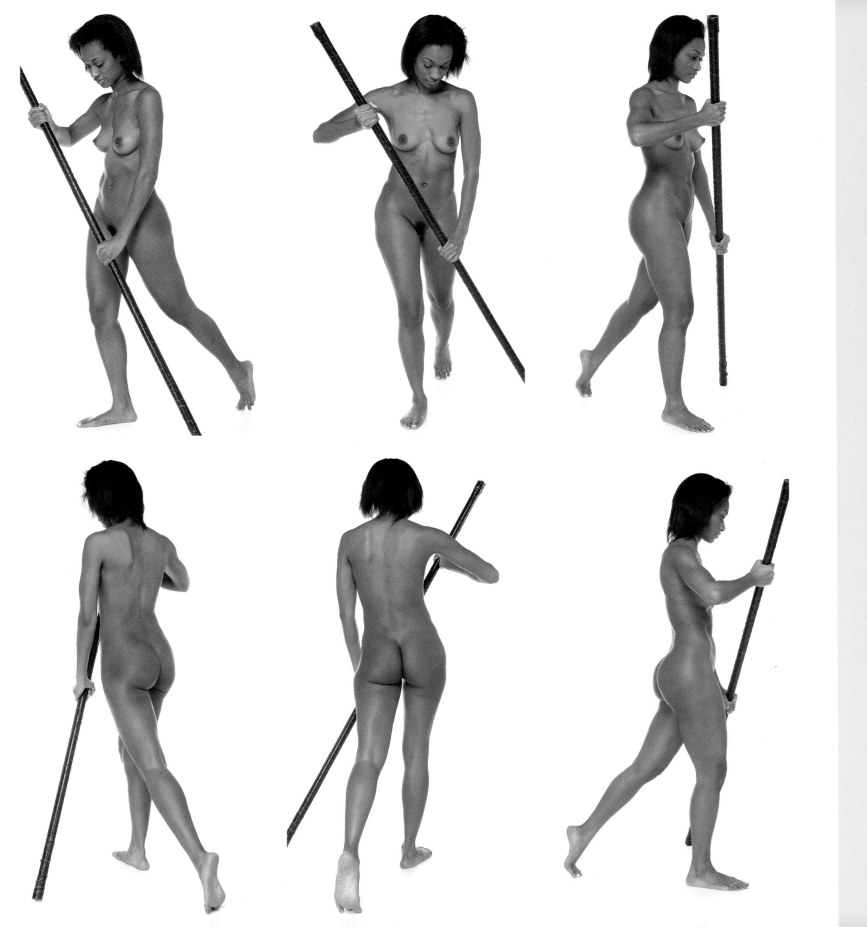

33

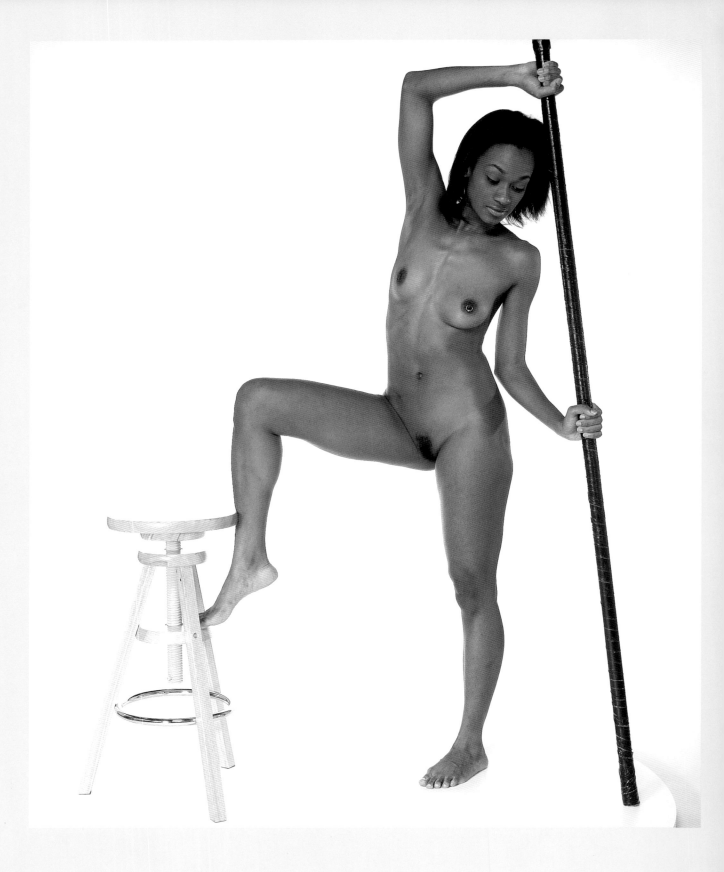

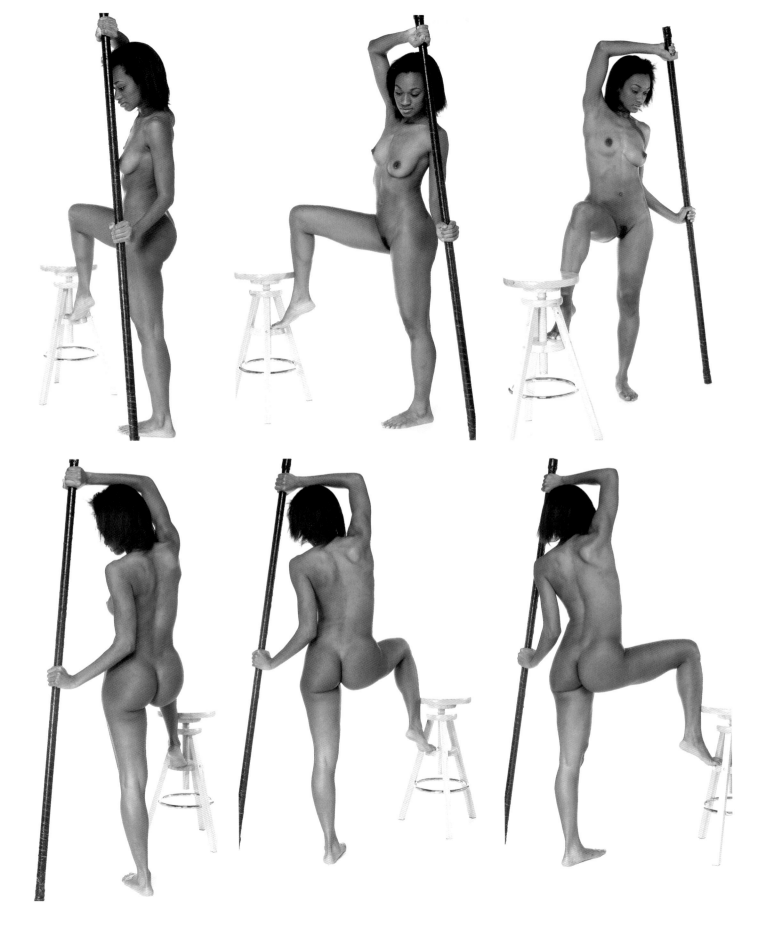

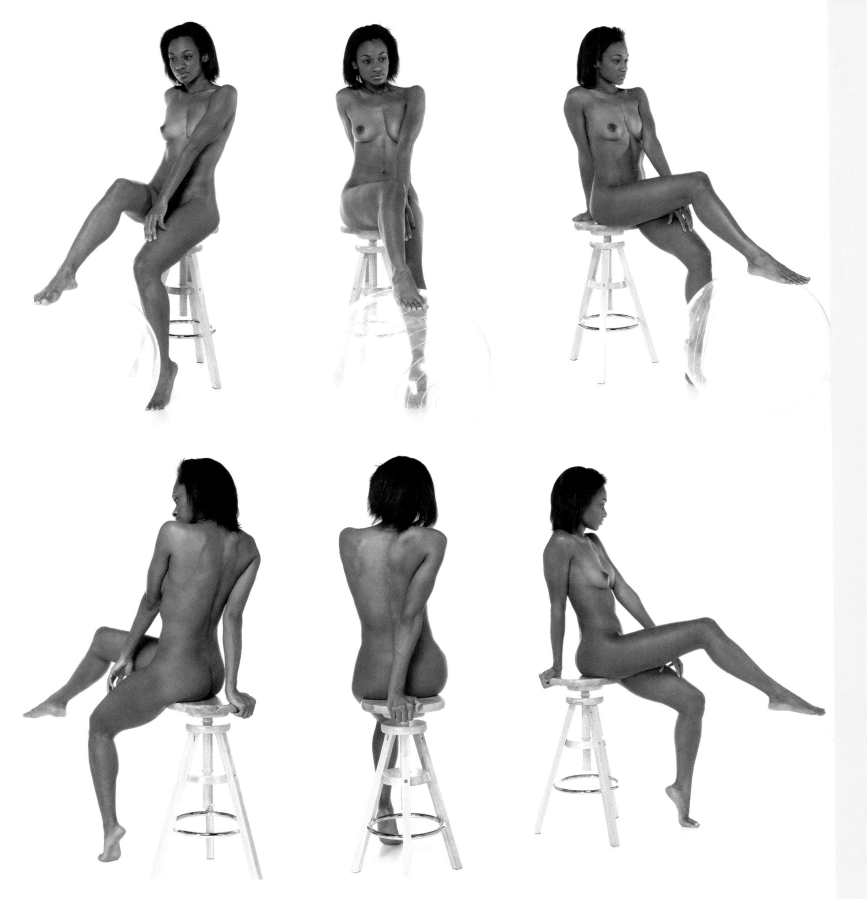

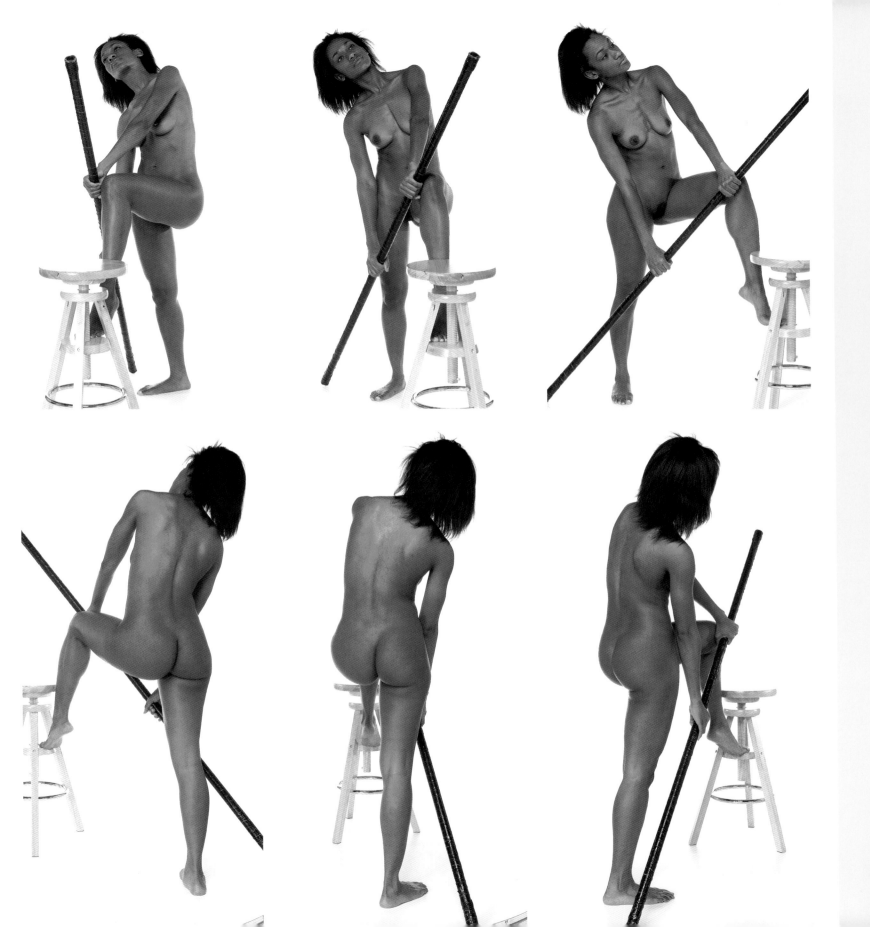

Ginny

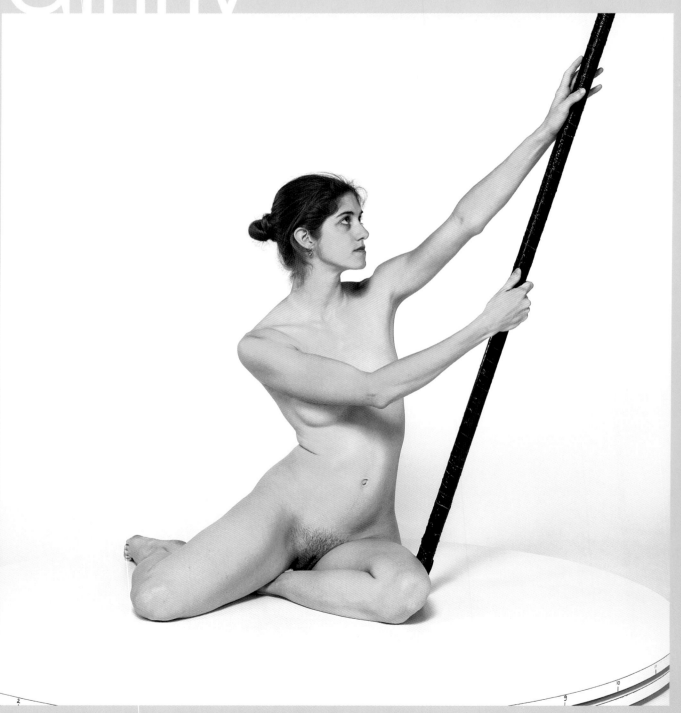

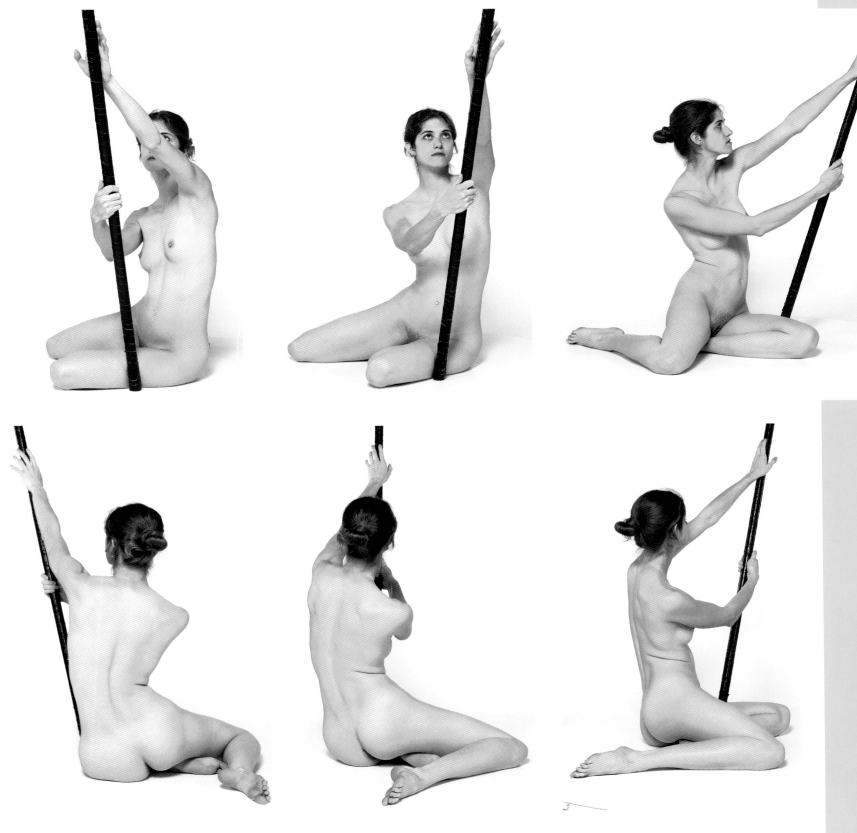

41

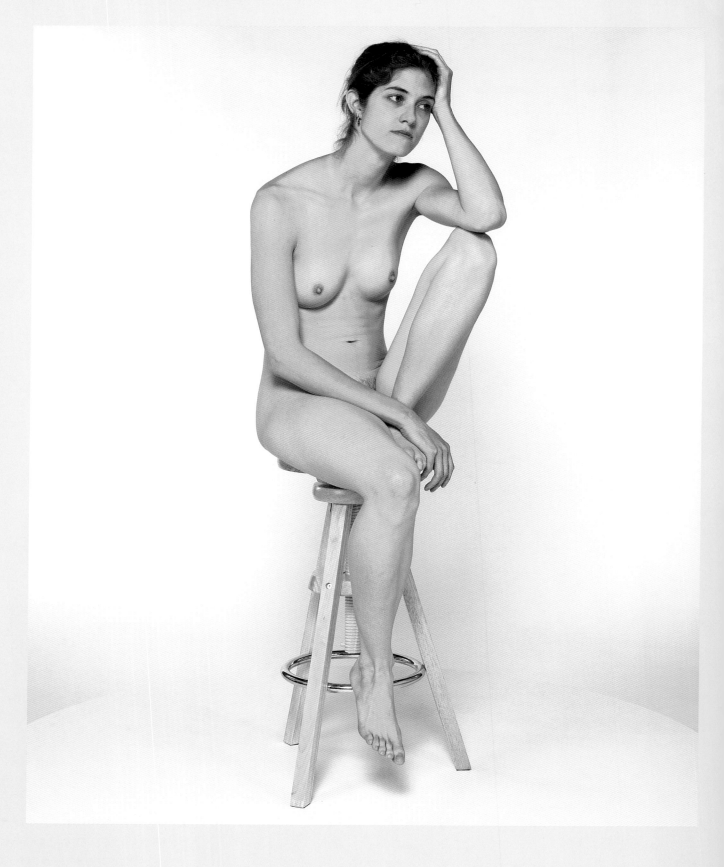

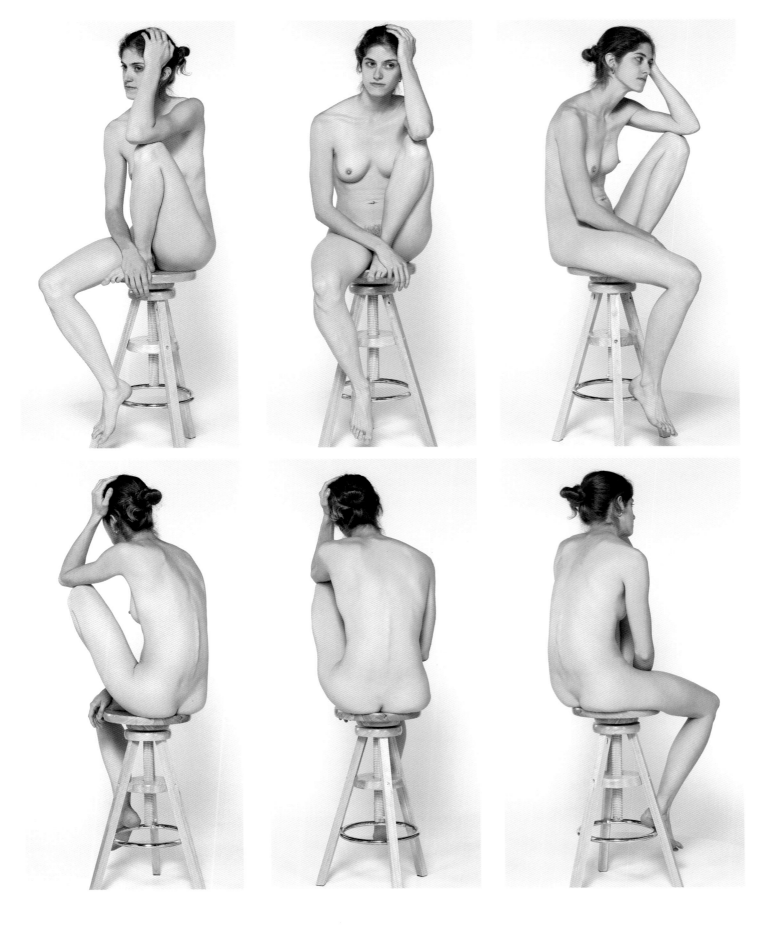

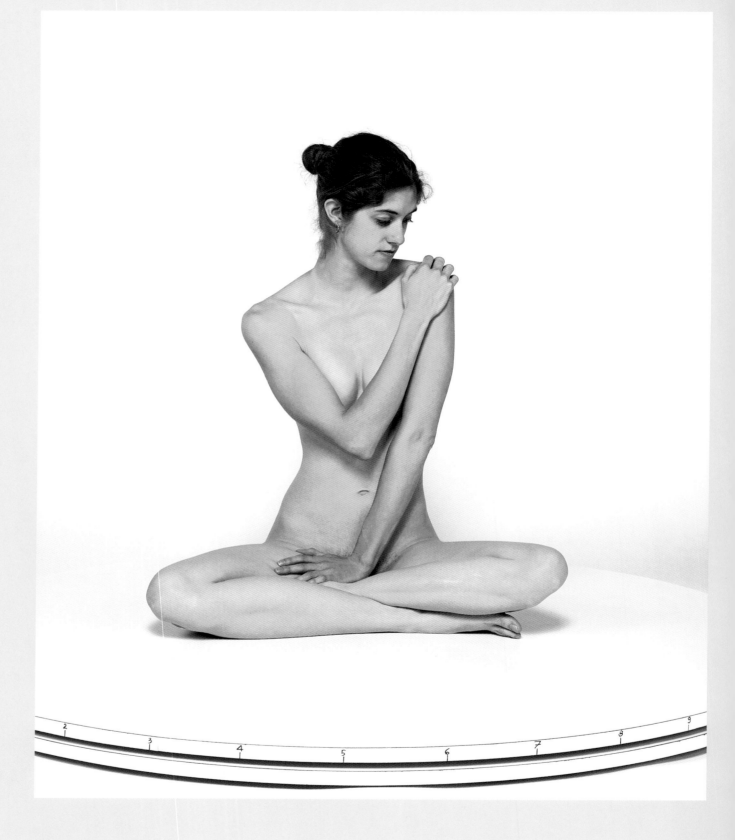

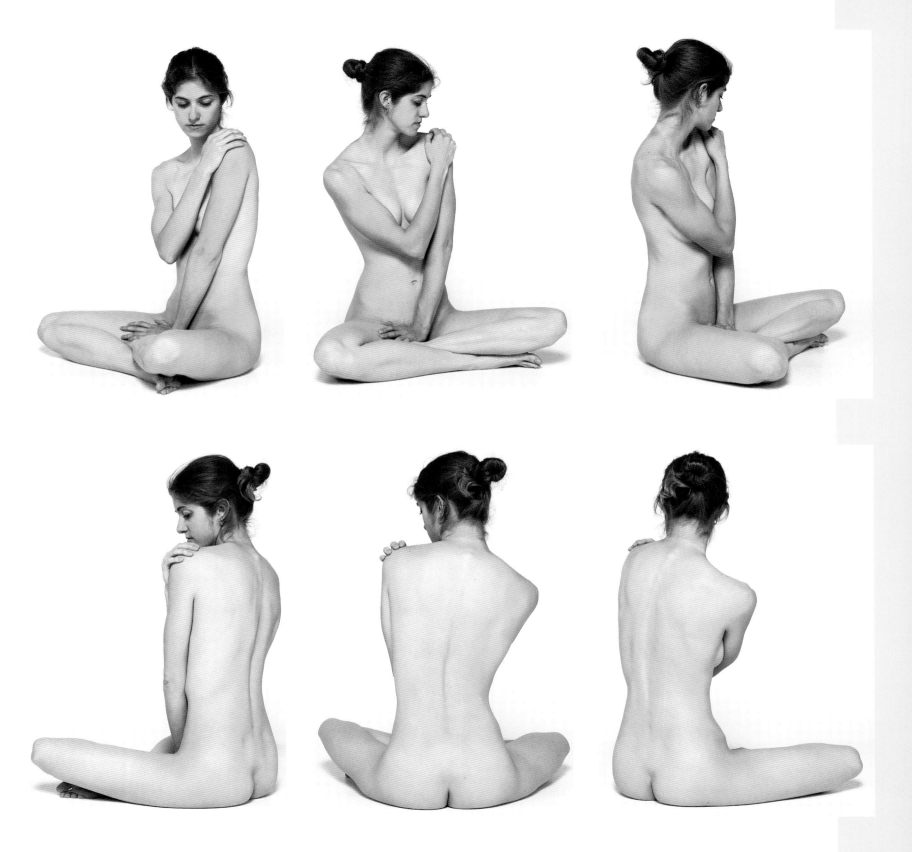

Afinity

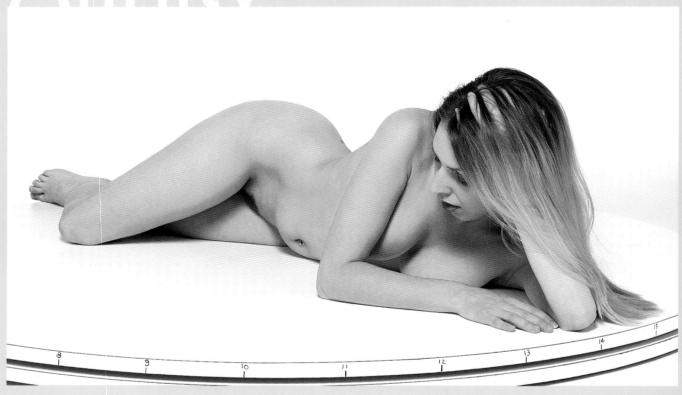

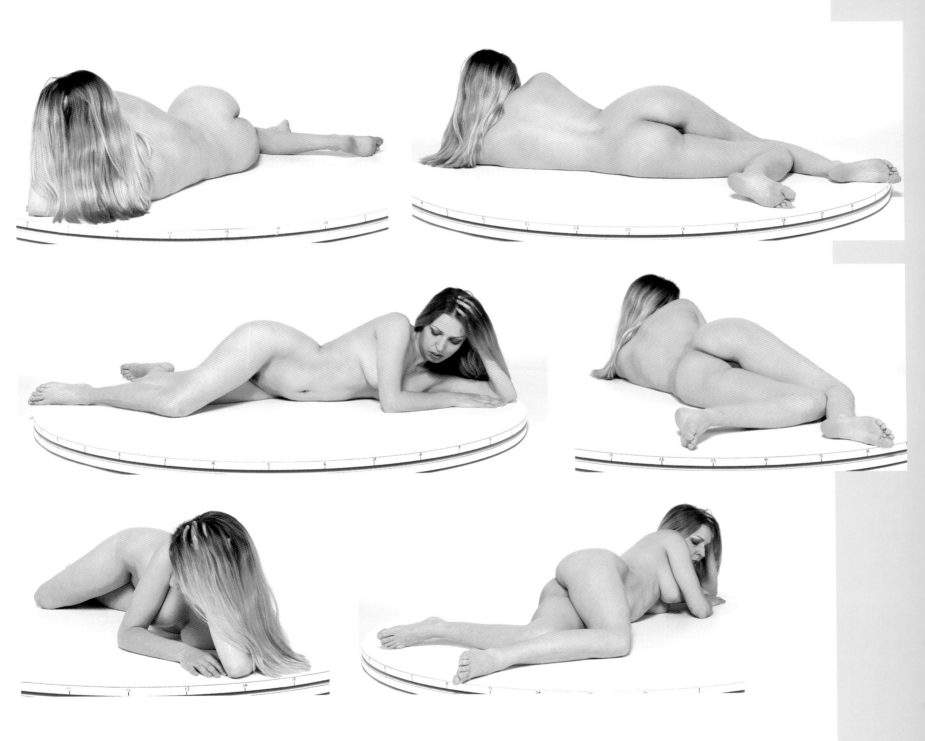

page
48

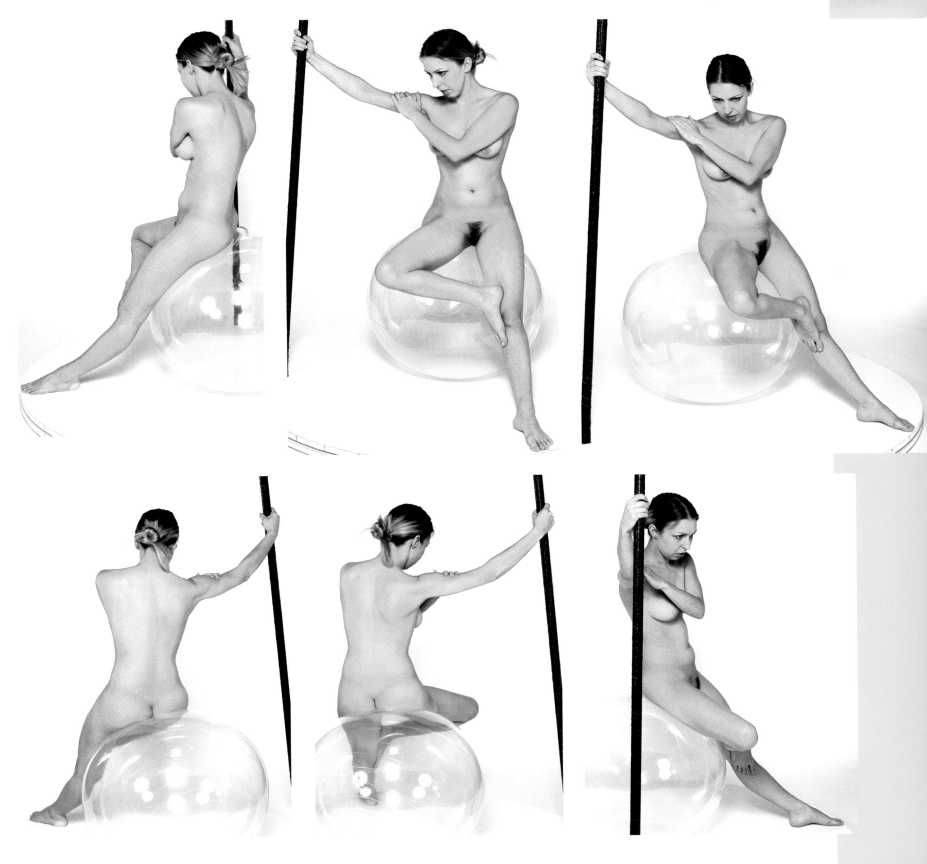

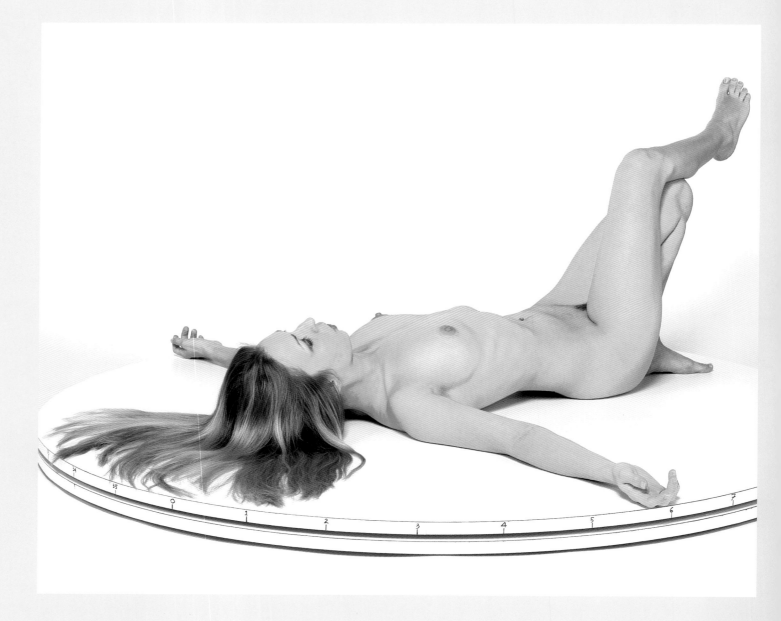

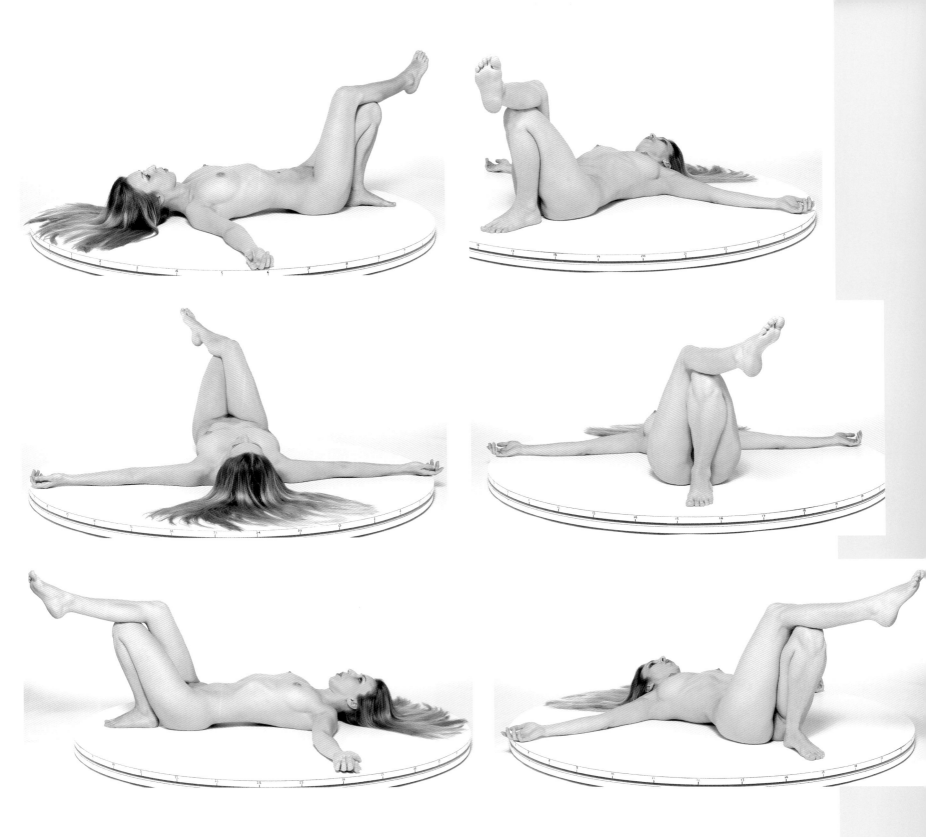

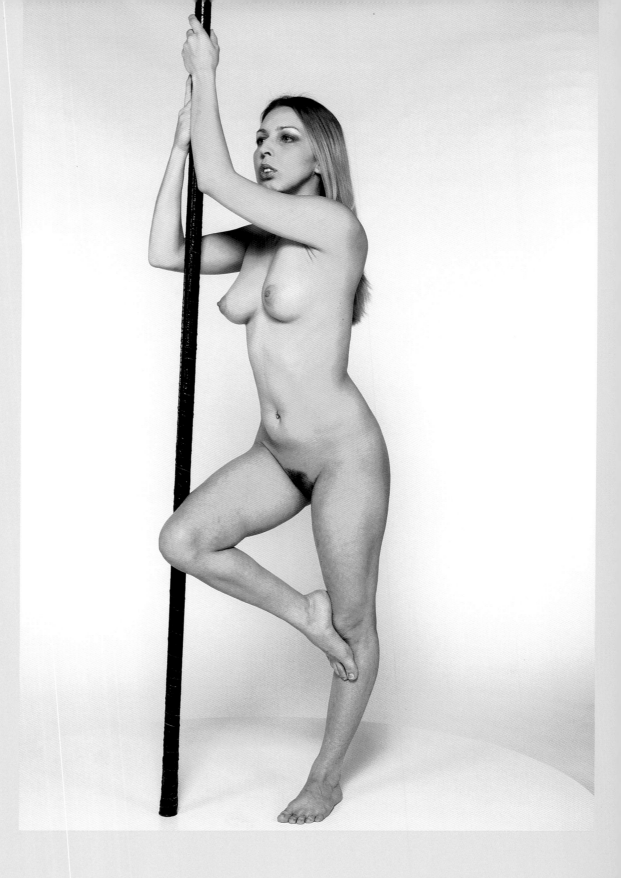

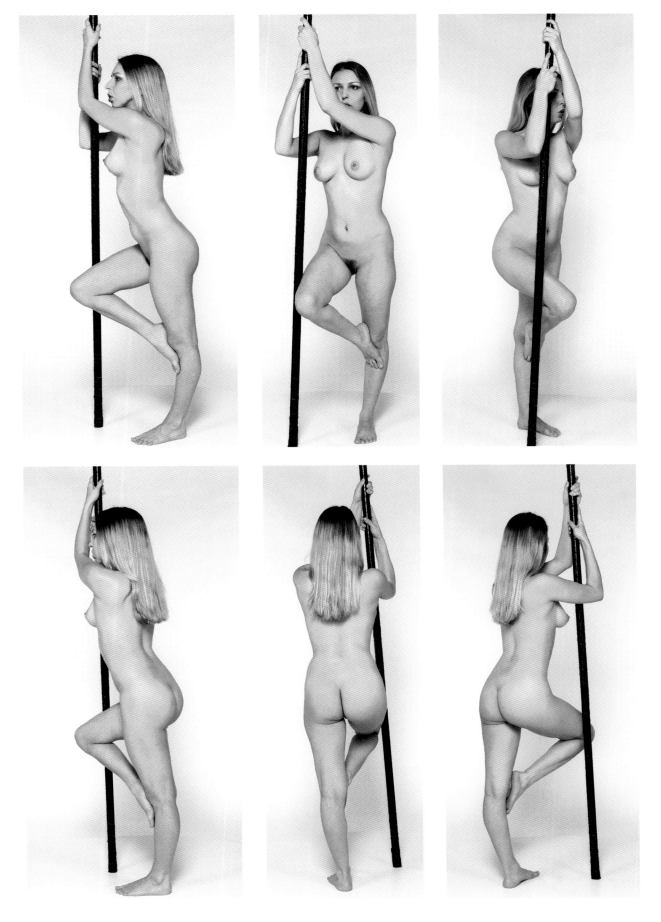

53

Pablo

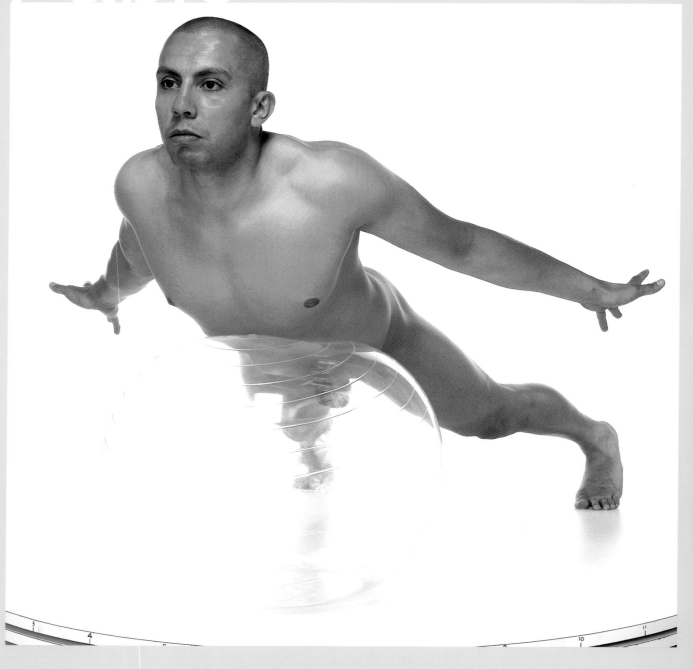

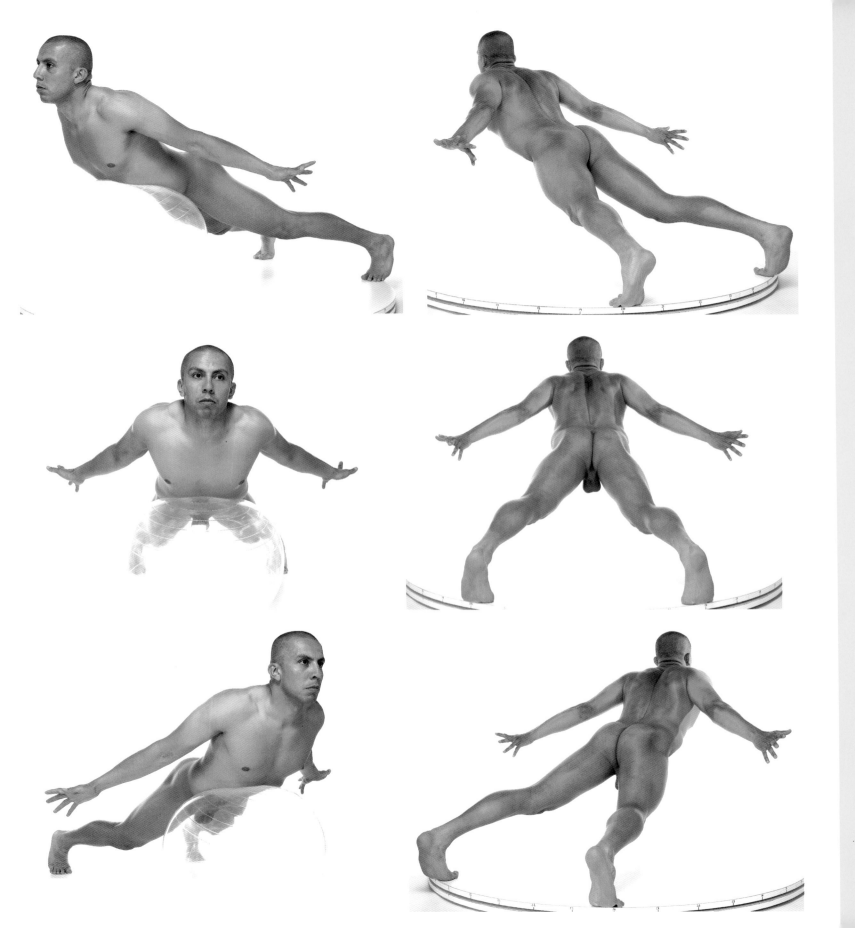

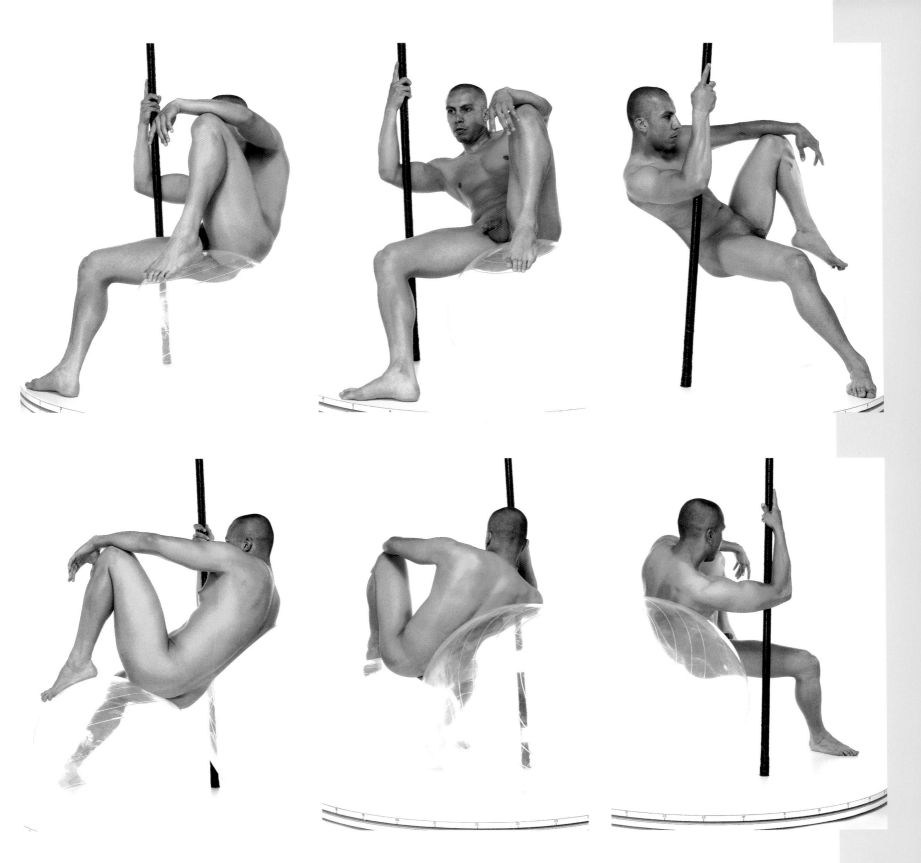

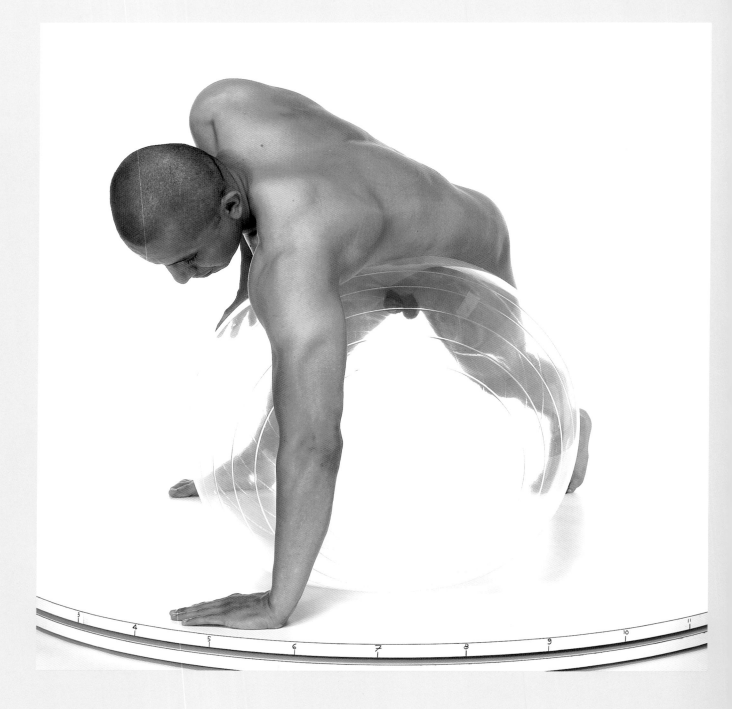

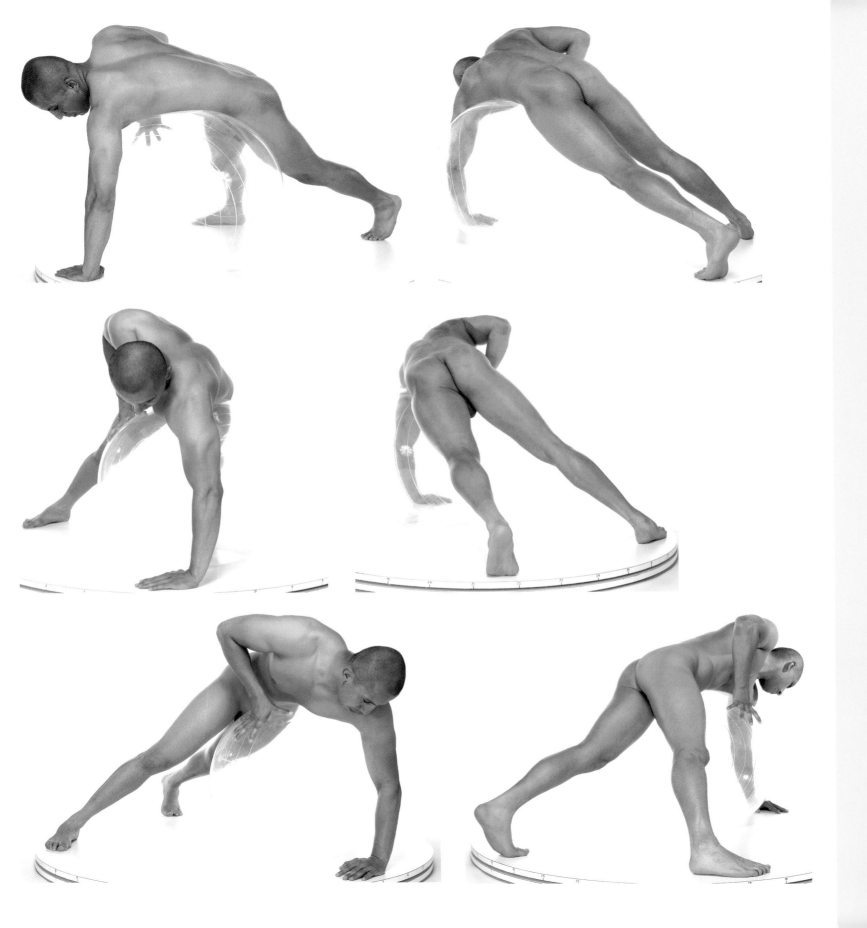

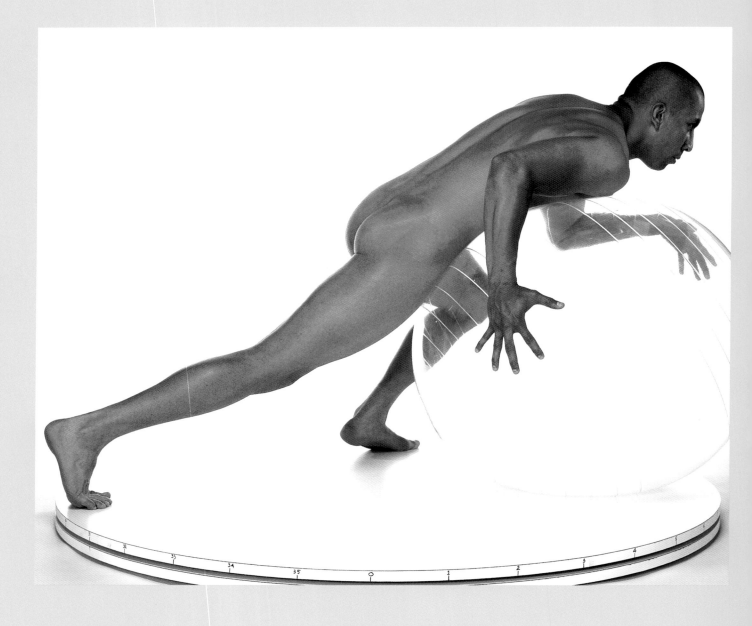

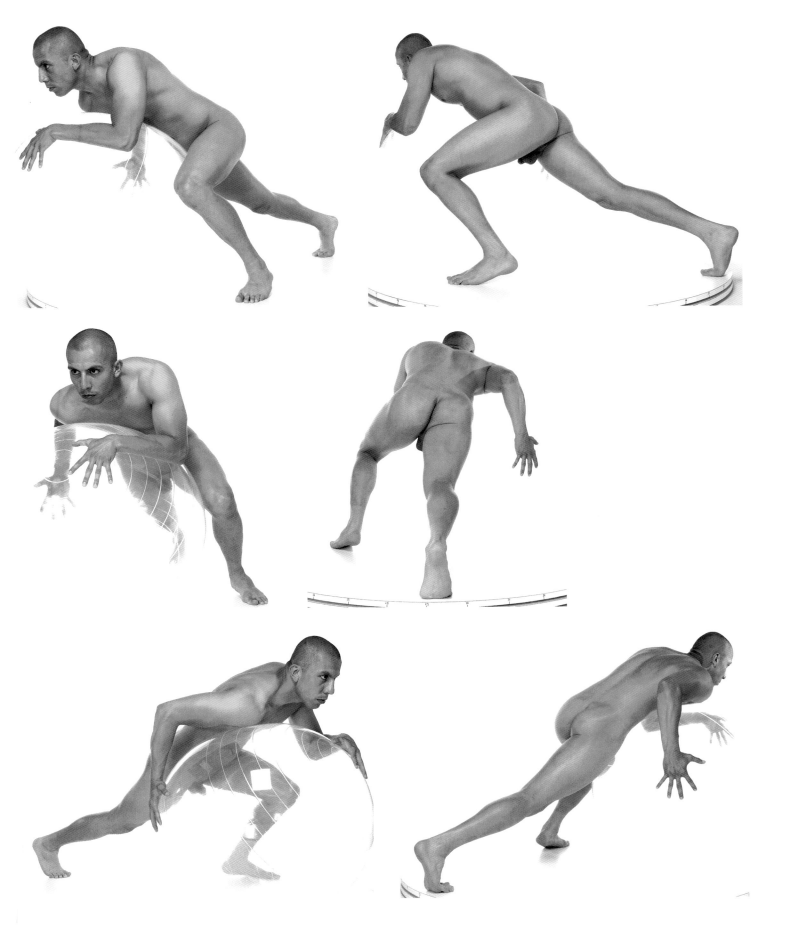

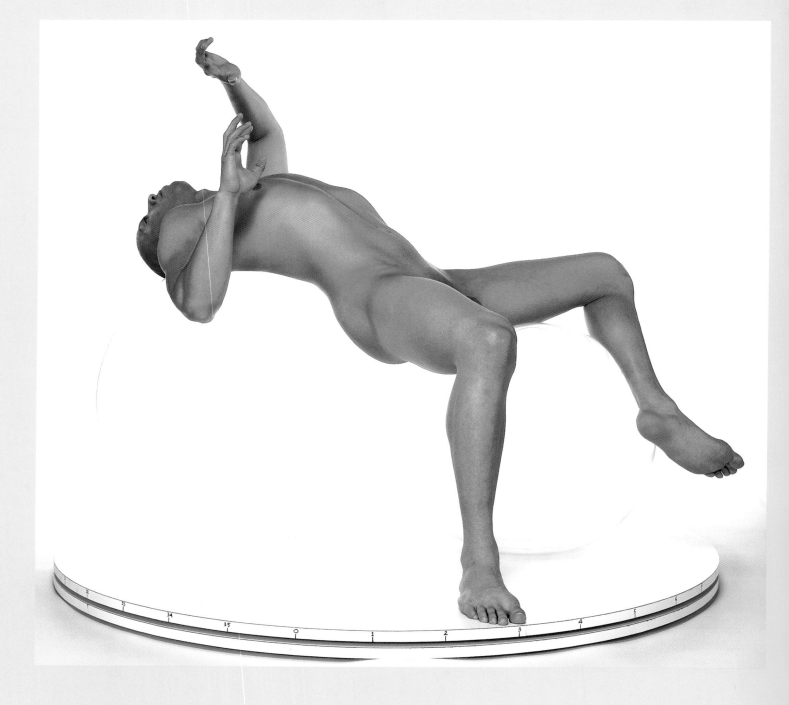

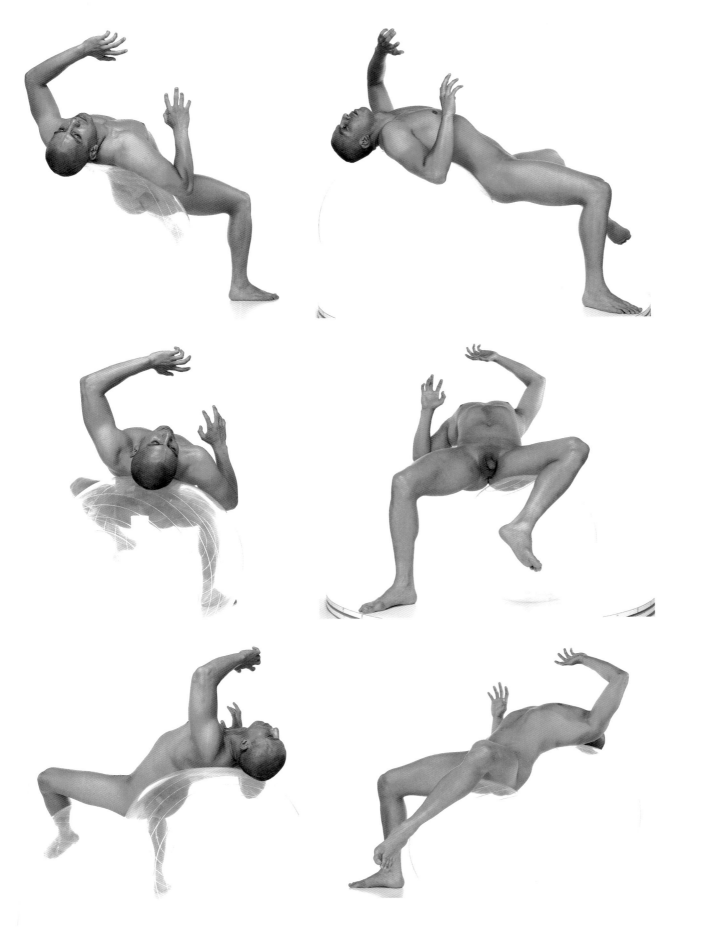

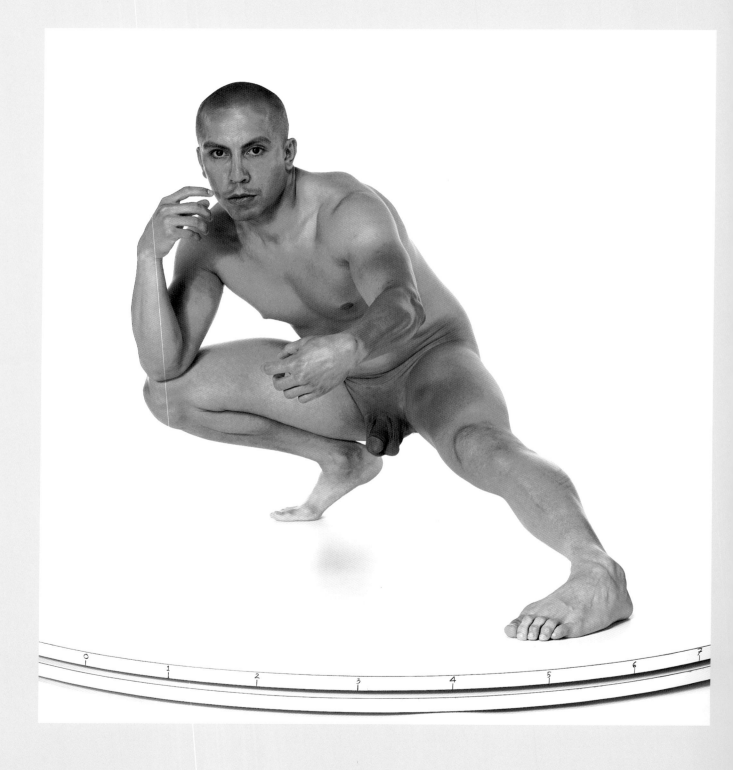

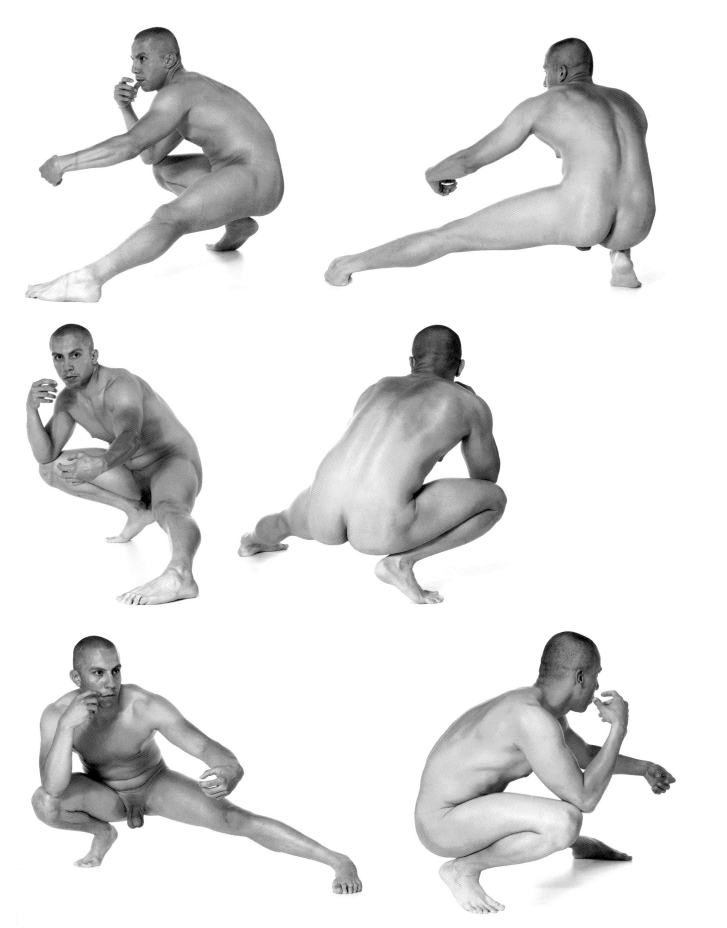

Mark

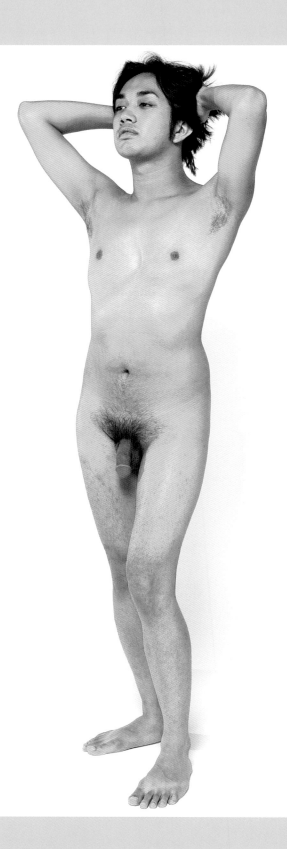

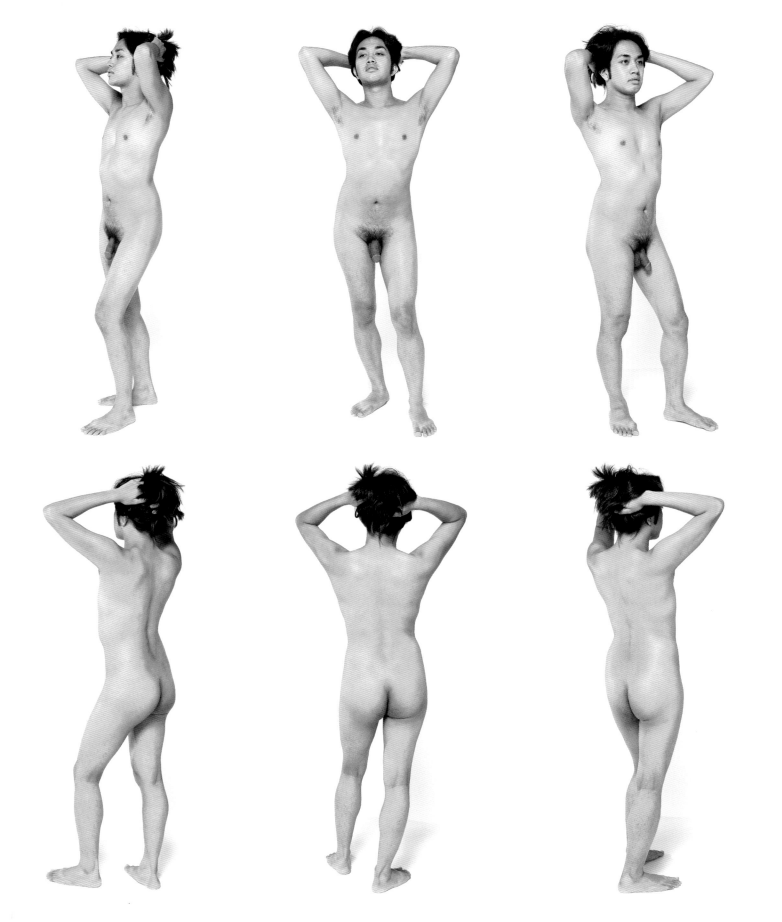

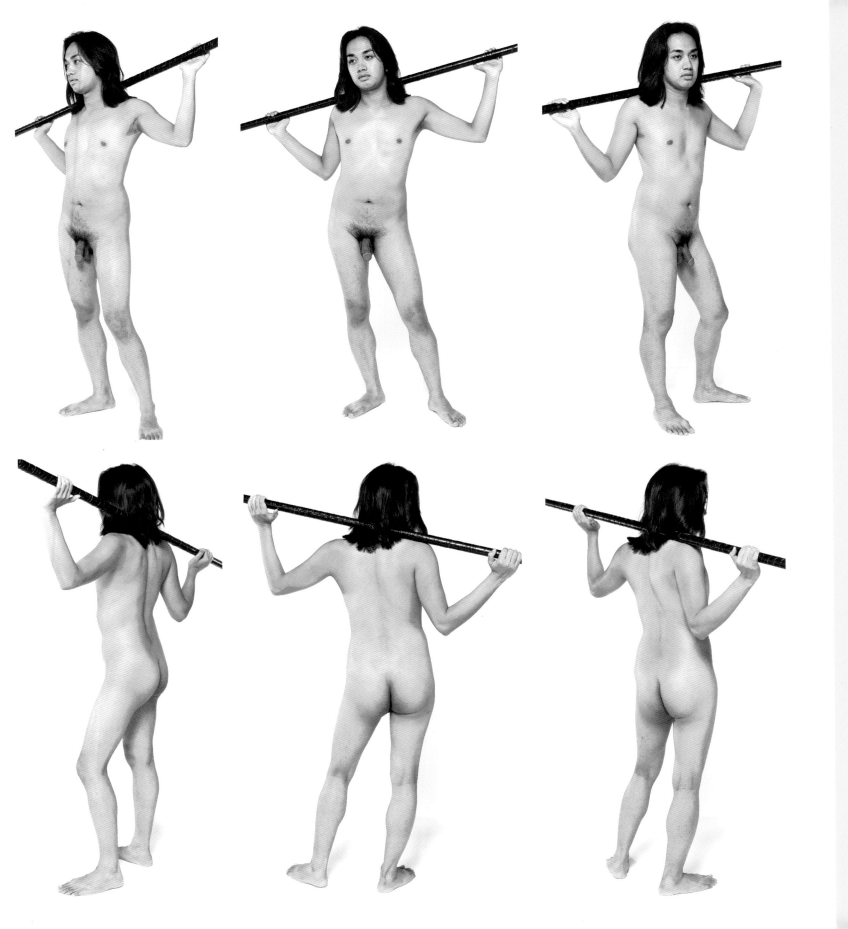

69

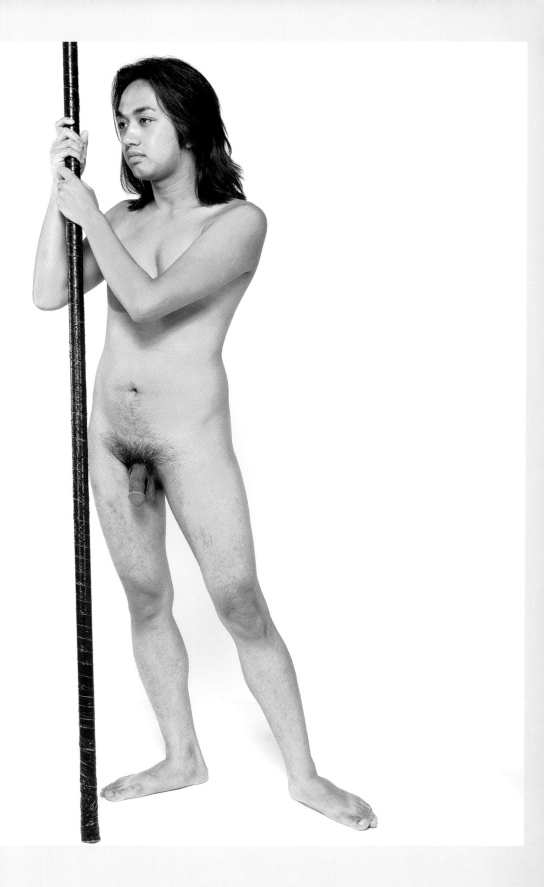

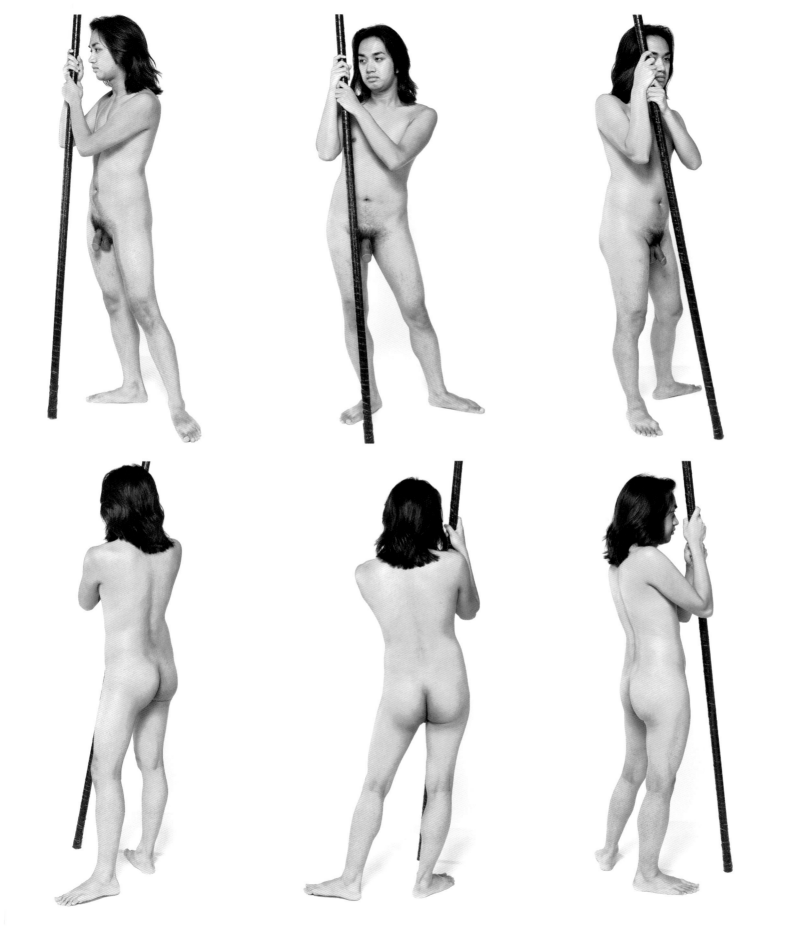

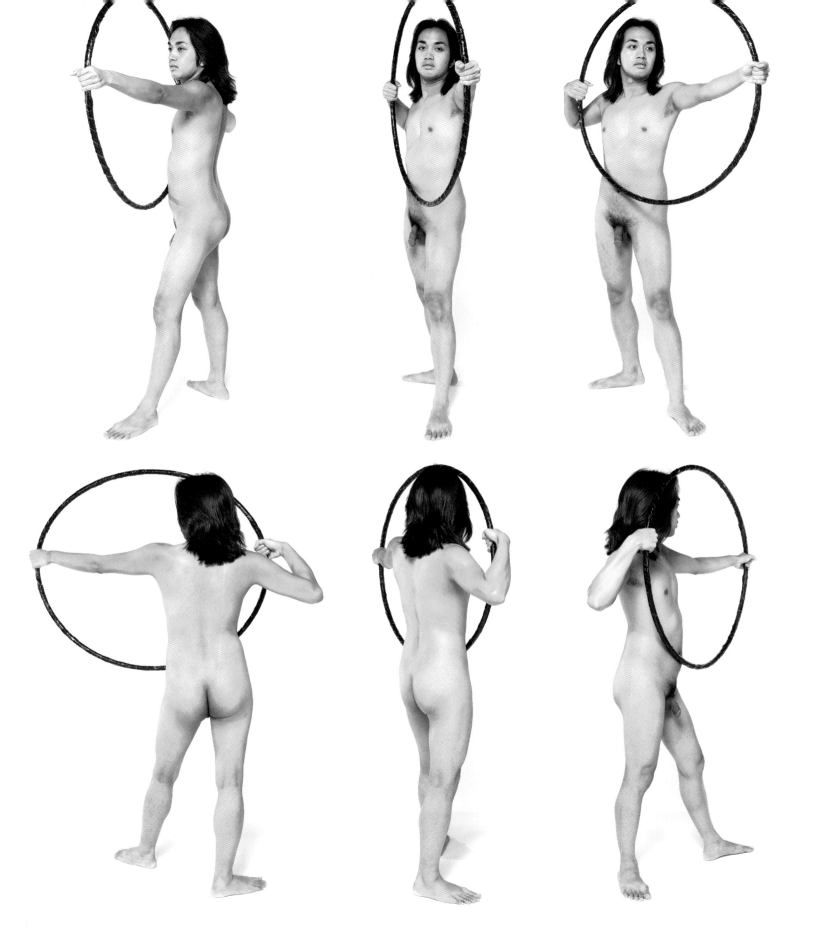

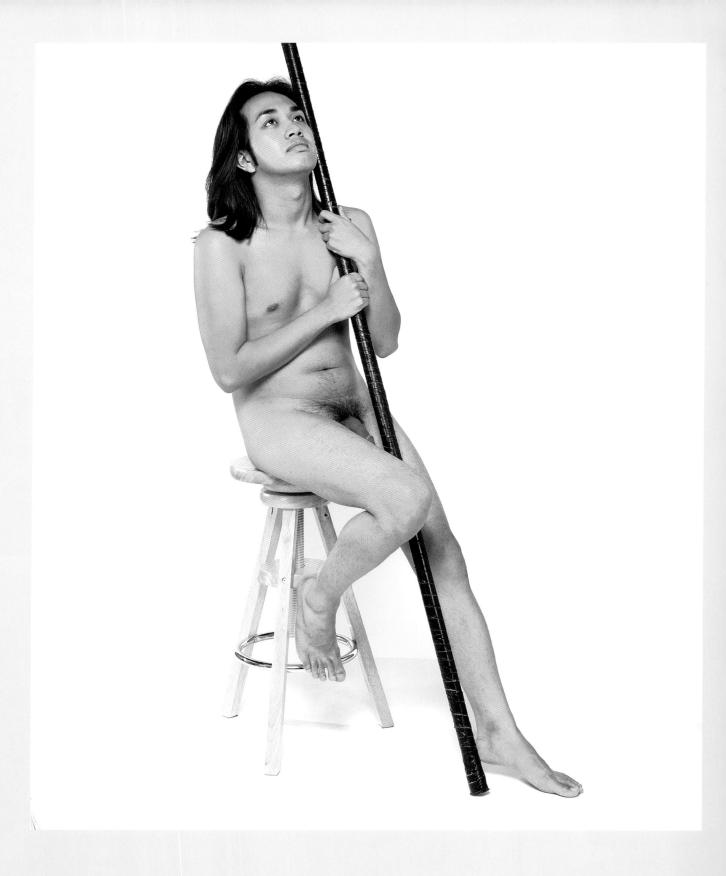

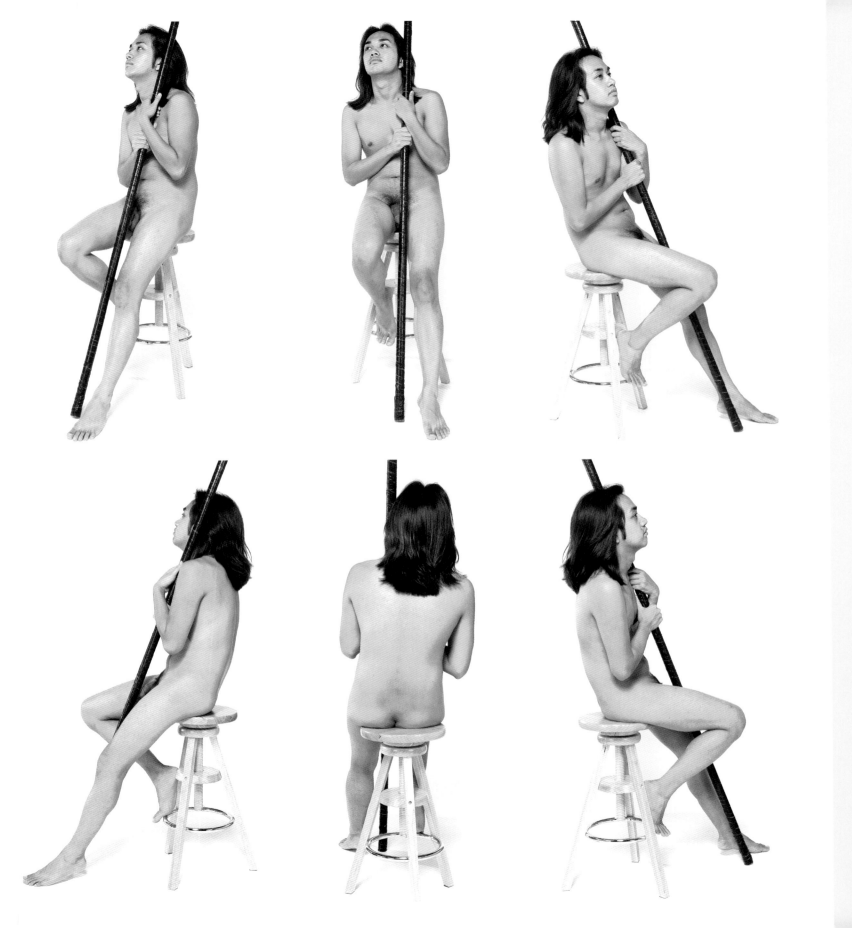

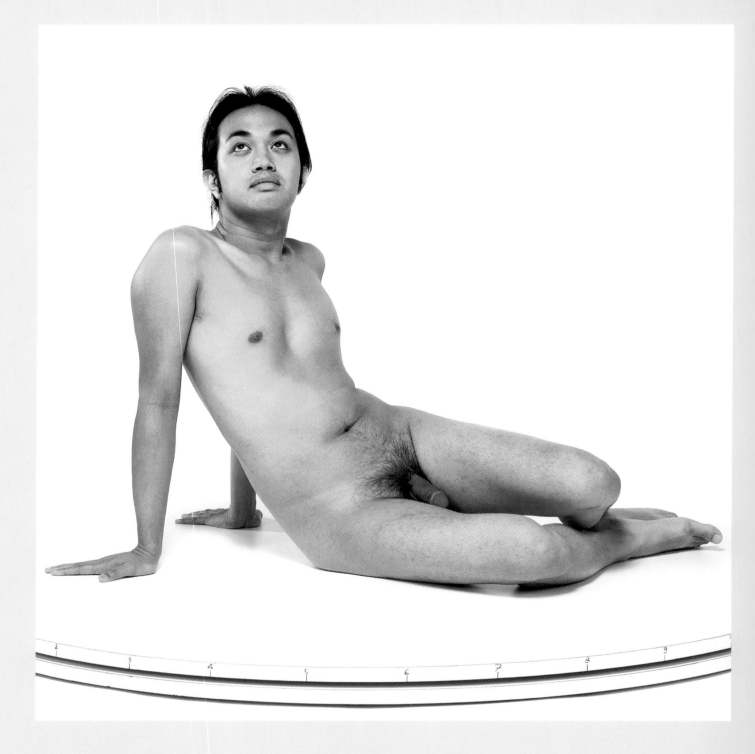

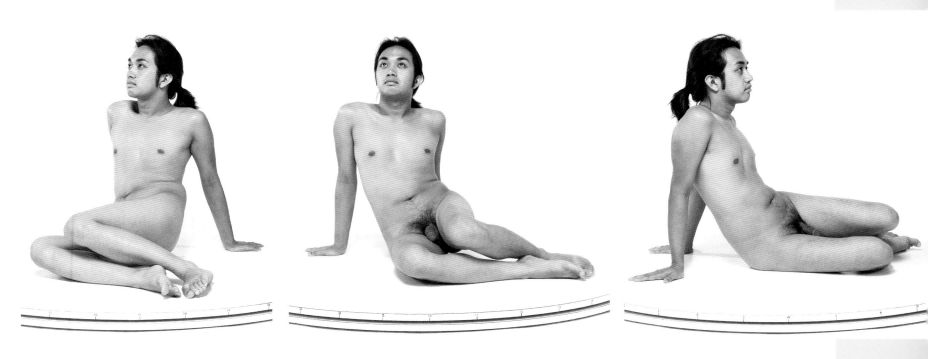

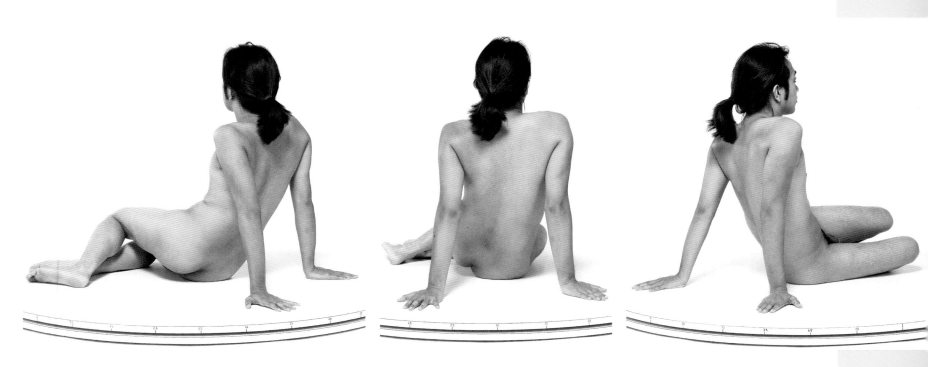

how to use this CD

MAC/WINDOWS

The VIRTUAL POSE® 4 companion CD-ROM located inside the back cover features 36 double-figure, double-high resolution*, color QuickTime VR (QTVR) poses (with 36 views each) you can play individually in the QuickTime (QT) Movie Player (provided on the CD), thus offering 1,296 total images to view and print!

*Based on Virtual Pose 3 image size standards.

LOCATING A POSE

Browse the book to locate a pose displayed in a two-page spread (per pose). Please note the LEFT PAGE NUMBER (Page 6, 8, 10, etc.), then locate the corresponding pose on the CD-ROM in "PosesFolder" by matching the pose name to that of the page number. For example, the pose on "page 6" of the book corresponds to file "Page_06" (or "Page_06.mov") on the CD-ROM.

LAUNCHING A POSE

Once the desired pose file is located, double click to launch it automatically** in the QT Movie Player. You may draw, paint, and sculpt with your Virtual Pose® reference image on the monitor screen, projected on a wall, or printed on a sheet of paper.

**Rarely, and depending on your system configuration, it may be necessary to manually launch the pose from within the QT Movie Player using the "FILE/OPEN FILE" command in the QT Movie Player application menu bar.

ROTATING THE POSE

To rotate the model, simply position the cursor in the middle of the QT Movie Player window, press the (LEFT) click button on the mouse and drag the mouse to the left or to the right. If using a tablet and digitizing pen, press the nib on the surface of the tablet and drag it to the left or to the right.

RESIZING/NAVIGATING AFTER ZOOMING

Once a pose is opened, you may resize it (reduce) to fit your computer monitor screen by using the "VIEW/ FIT TO SCREEN" command in the QT Movie Player application menu bar. To study the image in great detail on screen, we suggest keeping the view setting at "VIEW/ACTUAL SIZE" then ZOOM, DRAG, and ROTATE as needed. If under a particular zoom level you can no longer drag the image,

try zooming some more. We highly recommend that you increase your screen resolution to its maximum display ability as well.

PRINTING THE POSE

Choose "FILE/PRINT" in the QT Movie Player.

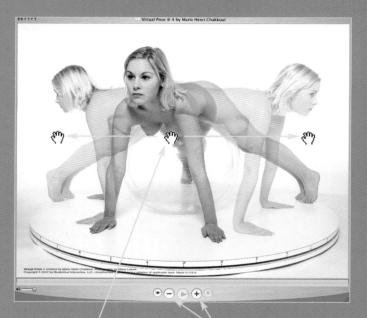

Cursor Tool
Cursor turns to hand once positioned over pose. Click and Drag to the left or to the right to rotate.

(If using a tablet and digitizing pen, press the nib on the surface of the tablet and drag to the left or to the right).

Magnification Tools
To enlarge the size of the pose, click on the icon with the "+" sign.

To reduce the size of the pose, click on the icon with the "−" sign.

RECOMMENDED SYSTEM REQUIREMENTS:

The VIRTUAL POSE® 4 companion CD-ROM is bundled with QuickTime 7.1.6 for Mac OS X v10.3.9 and v10.4.9 or later and QuickTime 7.1.6 for Windows 2000/XP. Upgrading your older version of QuickTime (QT) may not be necessary, especially if your system does not meet the system requirements. Older versions of the QT Movie Player can be found at the following web site: http://www.apple.com/support/quicktime.

System Requirements:
Mac OS X
- 400 MHz G3 processor or faster
- At least 128 MB of RAM
- Mac OS X v10.3.9
- Mac OS X v10.4.9 or later

Windows
- A Pentium processor-based PC or compatible computer
- At least 128MB of RAM
- Windows 2000 Service Pack 4 or XP Service Pack 2

QUICKTIME PRO

Given the larger resolution of the images available to you on the VIRTUAL POSE 4 companion CD, upgrading to QT PRO will allow you to export images in a multitude of formats, and print them FOR VISUAL REFERENCE ONLY in a better quality and size.

QT Pro Users Please Read: Installing the included QT Player will remove any previous version of QT that may have been installed. This will also invalidate your (OPTIONAL) old QT Pro Key and require that you purchase a new QT Pro Key to maintain your existing "Pro-Level" capabilities. YOU MAY NOT WANT or NEED TO DO THAT... the older version of QT may work "just fine" with the poses contained in VP 4. Therefore, before you upgrade (and potentially lose your QT PRO Key privileges, should you happen to own one) we recommend that you double click a pose and take it for a test-drive. You may also want to check the Apple Computer Company, Inc. QuickTime site: http://www.apple.com/quicktime/download to see if there is an even newer version available than the QT version shipped with VP 4.

This program is provided "as is" and without warranty. Hand Books Press disclaims all warranties, expressed or implied, and shall not be liable for damages resulting from the use or inability to use this program. QuickTime and the QuickTime logo are trademarks or registered trademarks of Apple Computer Company, Inc., used under license. VIRTUAL POSE is a registered trademark of StudioView Interactive, LLC., used under license. Windows is a registered trademark of Microsoft Corporation.

Produced by StudioView Interactive, LLC.

TERMS OF USE: The photographic images featured in this book and the accompanying CD-ROM are to be used as visual references only, and CANNOT be used, modified, or reproduced as photographic images — in whole or in part, in any medium or form, may it be electronic or print. Anyone who purchases a new and legal copy (with an unbroken CD-ROM seal) from an authorized reseller is therefore granted a license to produce and sell original artwork that may closely resemble the photographic images presented in the book and the accompanying CD-ROM. However, once the CD-ROM seal is broken, this license cannot be transferred or resold. If you purchased this book with a broken CD-ROM seal, the license is void and you can only use the images to create original artwork not intended for sale. If you resell your book and/or accompanying CD-ROM, you must destroy any legal back-up copy(s) and/or printouts. This product is licensed for individual and private, as well as RESTRICTED academic use only. Teachers wishing to use this product in their classroom in lieu of a live model can only do so if each student purchases his or her own copy — no exceptions! Any unauthorized copying, hiring, renting, public performance and broadcasting of the content is strictly prohibited. This program is provided "as is" and without warranty. Hand Books Press disclaims all warranties, expressed or implied, and shall not be liable for damages resulting from the use or inability to use this program.

Below are a list of keyboard commands that will allow you to fully operate your pose. Please note that you can move the image around inside the QT Movie window after zooming. Also, you can print a zoomed view!

MAC

To **ZOOM IN** (Increase Magnification): Press the **SHIFT** key.

To **ZOOM OUT** (Reduce Magnification): Press the **CONTROL** key.

To **DRAG** image (in ZOOM mode): Press the **OPTION** key, and drag with the mouse/tablet.

To **FIT TO SCREEN:** Press the **COMMAND+3** keys.

PC

To **ZOOM IN** (Increase Magnification: Press the **SHIFT** key.

To **ZOOM OUT** (Reduce Magnification): Press the **CONTROL** key.

To **DRAG** image (in ZOOM mode): Press the **CONTROL+ALT** keys, drag with the mouse/tablet.

To **FIT TO SCREEN:** Press the **CONTROL+3** keys.

"I would like to thank the following people and organizations for lending their time, support and resources…"

Afinity
Aristia
Sid Buck
Stephen Bridges
Carina
Thomas L. Cranmer
Melissa Demple
Robert (Bobbo) Goldberg
North Light Books
Gordon Goodman
Double Shot Studio
Carol Heyer
Ginny

Gustaf Van Acker
Mother Nature for cooperating with us!
Mark
Nadiyah
Candace Nirvana
Pablo
Paris, France
Redford, the Border Collie (seriously, how do you lay still for hours!?)
Shannon
Ludovic Sauvage
Michelle Simpson
The Washington School of Photography

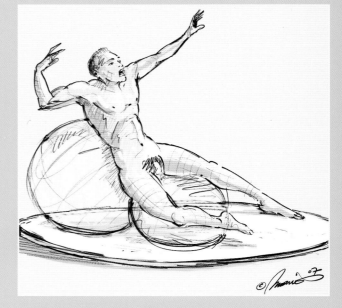

Sandrine, the "dynamo" who put the "dynamic" in VIRTUAL POSE 4 by choreographing fabulous poses and for supplying solutions to achieve the seemingly impossible! And of course, for reviewing thousands of model portfolios. By our estimate, over 3000 online portfolios were viewed collectively!

Missy, honestly, we wouldn't be "here" without you!

Salam, all I can say is that you've taken us from "here" to "way up there" with your level of expertise!

Beth, thank you for endowing the VIRTUAL POSE brand with its signature image, truly befitting its identity.

All our loyal friends and customers for their valuable support and honest feedback. In particular Mr. Darren Hunt.

Let us all rise and applaud Mr. David Michael Johnson for envisioning "Big Nellie" and Mr. David Robar for bringing her to life!

Last but not least, Salim Moussa Achi ("Doctor Dahesh"), founder of the Dahesh Museum in New York City, author, poet, and beloved guiding prophet. Your passion for the arts and unconditional respect for true artists were an inspiration as well as a model to aspire to. Shortly before your untimely passing, you said to me: "Just follow your inner vision." Those words became the constellation that has guided my journey ever since.

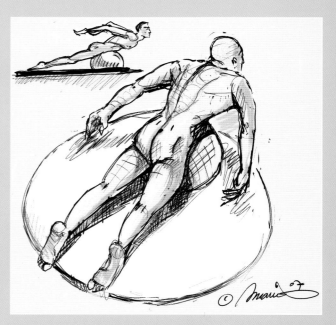